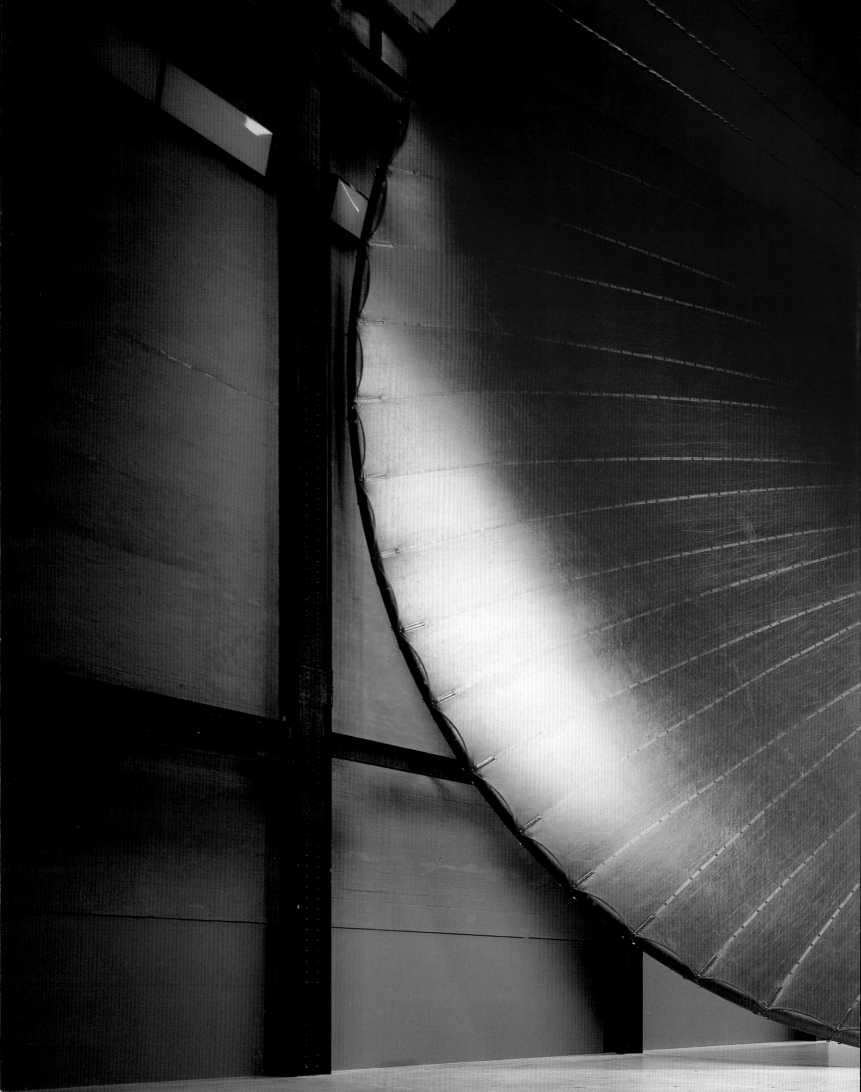

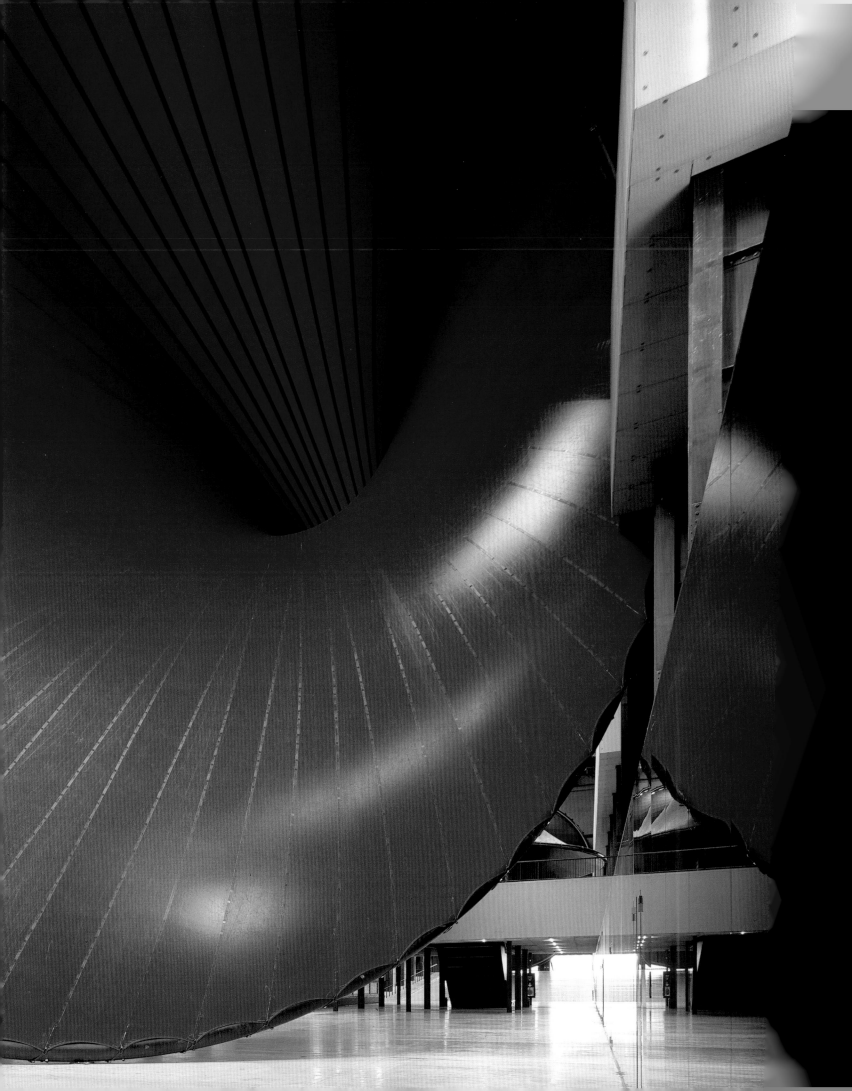

The Unilever Series

Anish Kapoor
Marsyas

Tate Publishing

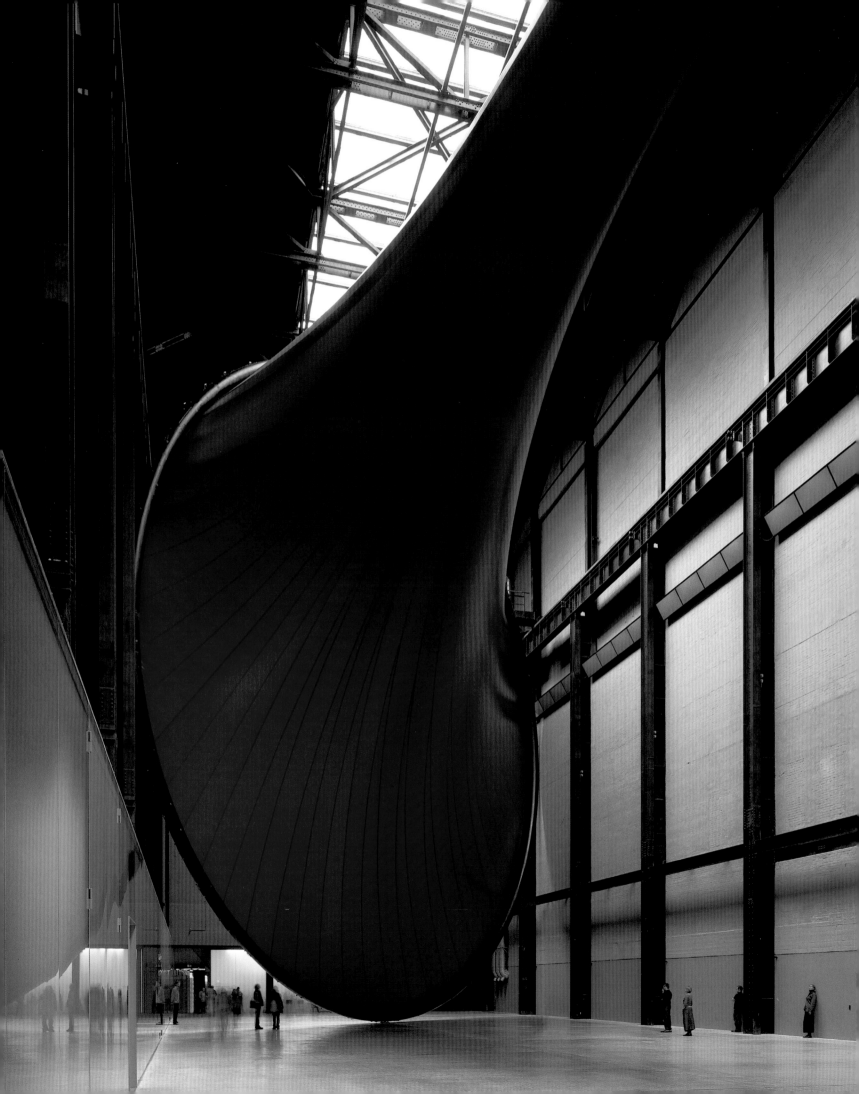

Contents

Sponsor's Foreword

The third commission in *The Unilever Series* has been undertaken by the internationally acclaimed British artist Anish Kapoor.

Drawing on the range and energy of his previous work, Kapoor's awe-inspiring installation has engaged fully the massive scale of Tate Modern's Turbine Hall, shattering the traditional demarcation lines between exhibit and exhibition space. If the purpose of art is to push back boundaries, to stretch minds and to challenge audiences, Anish Kapoor's work leaves the viewer gasping for superlatives.

The Unilever Series is a sponsorship that reflects how we work as a business: how serious we are about creativity, about enhancing quality of life through that creativity and about giving people the space to achieve the outstanding. We are delighted to be associated with Kapoor's installation which, in the spirit of *The Unilever Series*, is nothing short of breath-taking in its ambition, daring and sheer visual impact.

Anish Kapoor's work is a worthy successor to those of the previous artists, Louise Bourgeois and Juan Muñoz in the first two years, and maintains the very highest standards of dynamism and innovation we have come to associate with Tate Modern. Quite simply, it is a masterpiece.

Niall FitzGerald KBE
CHAIRMAN, Unilever

Foreword

It is both a challenge and a thrill for an artist to be asked to create a work of art for Tate Modern's Turbine Hall. It is a space of enormous scale and has been described as the twentieth-century equivalent of the Duveen Galleries at Tate Britain. The support of Unilever has given us the opportunity to establish a forum in which leading artists can pursue their creative ambitions in an unbridled fashion. It is fitting that Anish Kapoor, one of the foremost figures of his generation, should be the first British artist in this series. Tate has had a long-standing relationship with Anish Kapoor, winner of the Turner Prize in 1991. Our sincere and heartfelt thanks go to him for his courage and vision in realising a truly extraordinary project. His enthusiasm and goodwill have made this collaboration a pleasure.

In creating *Marsyas*, Anish has worked especially closely with two people: Cecil Balmond, Chairman of the European Division of Arup, and Donna De Salvo, Senior Curator at Tate Modern. Since the project first began in January 2002, Cecil has been instrumental in translating Anish's vision into reality. Assisted by Chris Carroll and Tristan Simmonds, Cecil's dedication to this project has been extraordinary and we are delighted that his collaboration is marked in this catalogue with an essay that traces the evolution of the piece.

At Tate Modern Donna De Salvo has managed and curated the project with enormous skill and dedication. Assisted by Sophie Clark, Donna has worked closely with Anish on all aspects of the work from its inception to completion. Her essay and interview with the artist offer important insights into the relationship between process and meaning. We are also very grateful to Phil Monk, Alan Froud and Sharon Hughes for their unstinting efforts to realise this project from the technical and logistical side, along with Brian Gray and Dennis Ahern. Nadine Thompson, Sioban Ketelaar and Calum Sutton have skillfully coordinated the enthusiastic interest of the press.

Such a project could not have been achieved without enormous commitment from the contractors who worked with us. We would particularly like to thank Klaus-Michael Koch, Director, and all the team at B & O Hightex, as well as the fabricators of the steel and fabric components of this work, Shstructures and Ferrari.

We are also extremely grateful to Barbara Gladstone Gallery and Lisson Gallery for their additional support.

This catalogue is a testament to the collaborative nature of the project as a whole. We are very grateful to Philip Lewis for his imaginative design, incorporating installation photographs by John Riddy, Marcus Leith and Andrew Dunkley. Nicola Bion and Emma Woodiwiss have steered the book calmly through the editorial and production process.

Finally, I would like to thank Unilever and their Chairman Niall FitzGerald for their long-term support and commitment to Tate and The Unilever Series. Without Unilever a project of this importance and scale would simply not be possible.

Nicholas Serota, DIRECTOR

ANISH KAPOOR MARY HAY PRO 8

Making Marsyas

DONNA DE SALVO

'The form, I insist, made itself'[1]

ANISH KAPOOR

Tate Modern's Turbine Hall, or what was left of it when it was emptied of the vast machinery once essential to the Bankside Power Station, is a deeply evocative space. Some critics have gone so far as to describe it as a 'secular cathedral'. It might, in fact, even be imagined as a monument to the Industrial Age except that without its gigantic turbines, the phrase post-industrial seems more accurate. Whichever term one chooses to describe this 150-metre-long space, with its steel beams reaching up over 35 metres, what is undeniable about it is its massive scale.

During the planning stages of the programming for Tate Modern, a decision was made to commission a series of artists to develop projects for the Turbine Hall. Implicit in the museum's decision to use the Hall as an exhibition space was a curiosity about *how* the space might be occupied. Anish Kapoor was asked to become the third artist, and the first British one, to grapple with this problem.

Pinned to the wall of Kapoor's South London studio is a drawing made while he was a student at Hornsey College in 1973. In it a simple line moves across the page as it articulates a square that becomes a circle. The drawing had been produced with a computer, the result of the artist's early experimentation with technology. Kapoor selected a square and circle and the computer generated what came in between. Looking at the drawing, it is difficult to determine where the line begins and ends or what, if any, object is being described. Kapoor's forms typically confound spatial perception in this way and one of the factors that led to his selection for the Unilever series was an interest in the way the complex forms he is identified with might play in a room as massive as the Turbine Hall.

Architecturally the Turbine Hall serves as both an entrance and an exit. Kapoor's first impressions of the Hall, still under construction, were of a place of both arrival and departure, a transitional space. Herzog &

de Meuron, Tate Modern's architects, inserted a bridge into the middle of the Hall to move visitors between the second and ground-floor levels, and to make a path eventually from north to south through a section of the building yet to be developed. It is a feature that would later play a major role in the development of Kapoor's project, as the bridge divided the space in two, restricting the use of the entire length of its floor.

Since its opening in 2000, two other artists before Kapoor have completed projects for the Hall: the American artist Louise Bourgeois, and Spanish-born Juan Muñoz. Each opted to explore the terrain at the east end of the Hall, contained space created by the bridge. Bourgeois placed three steel towers in this space for her sculpture, *I do, I undo, I redo*, 2002, accompanied by *Maman* placed on the bridge. Through stairs built into each tower, individuals were directed upwards into them, one at a time, and then, in a gesture suggestive of the birth act itself, delivered onto a platform from which they could look out at the vastness of the Turbine Hall. Juan Muñoz's *Double Bind*, 2001, masterfully connected the two levels of the Turbine Hall through a pair of sculptural mise-en-scenes. The work had a frontal view, framed by the architecture, but it was never possible to experience these tableaux at the same time. One had to ascend to the second level, and then descend to the ground floor below. What linked both was a set of lifts bisecting them and traversing the cavernous hall, from top to bottom and back.

Both of these commissions would have been inconceivable were it not for the vast height of the Turbine Hall, a space with few precedents in the history of museums of modern art, and this is also true of the Anish Kapoor project. The very first time the artist saw the space, he was also impressed by its verticality. But, curiously, his impulse from the outset was to tackle the daunting height of the Hall by emphasising its opposite, the horizontal.

Over the course of his career, Kapoor has made sculptures notable for their downward energy, what might even be called an anti-verticality. The massive

1 Anish Kapoor in conversation with Donna De Salvo, June 2002

concave dome that was attached to the ceiling of the Hayward Gallery, *At the Edge of the World*, 1998, may at first have seemed blatantly vertical; however, it took the viewer on a physical journey in which they too were finally drawn downwards and back to the horizontal span of floor beneath their feet. He has embedded forms directly into the floor, as with *Turning the World Inside Out II*, 1995. Here, a concave circle of highly polished stainless steel forces you to look down into it as its surface reflects back whatever is above – other viewers, the architectural details of the ceiling. Inevitably, once you have looked up, you are again compelled to look back down, perhaps to contemplate what lies beneath the steel.

Many of Kapoor's earliest works, such as *Untitled*, 1978, occupied the entire floor of a room. This installation in the artist's studio comprised fragments of chalk dispersed on the floor, as well as electric motors and silks. The studio was divided by two large transparent screens that filtered a view of small spheres positioned on stands. The work was strongly pictorial in its engagement with surrounding space, an overall field that was reminiscent of the canvases of Jackson Pollock. As Kapoor's work evolved, he continued to make ensembles, but the forms within them became more solidified, pushing up from the ground and into the surrounding space.[2] He also continued exploring the sculptural possibilities to be discovered through an array of materials. A now much cited trip to his birthplace in India reacquainted Kapoor with its cultural practises, and led him eventually to use some of the materials he had seen there, including powdered pigments. Though trained in the West, and as influenced as any by the cultural histories of European and American art history, Kapoor encountered something that would have a profound impact on his thinking, the first aesthetic manifestation of which was *1000 Names*, 1980.

Kapoor has spoken of his desire to separate object from objecthood and unite the object with space. In the powdered pigments he found a material that, aside from its overt association with Indian culture, allowed him to

blur the clear lines of a given form's edge. As in *1000 Names*, this use of the powdered pigments worked to dematerialise the object just enough to suggest a continuity between object and space.

Much has been written of the perceptual and metaphysical implications of Kapoor's use of space, and especially the voids, which are an integral part of his formal language. Art historian Pier Luigi Tazzi, for example , has commented, 'The internal void contains everything and nothing, and it is the latter that substantiates it. The act of an artist consists in opening the rigid surface (of the world) upon that abyssal void that constitutes its substrata rather than its essence.'[3] In the powdered pigment surfaces of *1000 Names*, Kapoor visualises the space that lies beneath its surface, but reveals nothing about it. *Hole and Vessel II*, 1984, also circumscribes a space, but the title accomplishes linguistically what the sculpture does on a formal level. Here, we experience the sensation of contained space, as if trapped for future microscopic study. The form of the object vibrantly, even aggressively, pushes out into surrounding space, and yet it is the hole that punctures its surface, and opens up the dark void to which we are ultimately drawn. As the artist has observed, 'The space contained in an object must be bigger than the object which contains it.'[4] The object here is merely a gathering of substance amidst the void. What lies beneath the surface, then, is not an *essence*, but many layers, an infinity. This notion of continuous space is a fundamental aspect of Kapoor's work.

In 2000, Kapoor had exhibited at Lisson Gallery a cube construction of foam-core and nylon. A swath of red nylon tights was pulled from one side of the cube and attached to two of its opposing walls, creating a space within a space. Ephemeral in nature, it had the feel of a three-dimensional sketch that could be held in the palm of your hands. That same year, Kapoor had been commissioned by the Baltic Art Centre to work in the shell of its empty and gutted building, a former flourmill in Gateshead, in the north of England. The immense scale of this former industrial site was unlike anything

2 See Lynne Cooke's excellent essay on the early work, 'Mnemic Migrations', in *Anish Kapoor* exh. cat. Kunsthernes Hus Oslo, 1986, pp. 5–17

3 Pier Luigi Tazzi, 'Journey', in *Anish Kapoor*, exh. cat., Hayward Gallery, 1998, p. 104

4 Anish Kapoor in conversation with Donna De Salvo, June 2002

he had had the opportunity to work with before. He stretched a fabric membrane of industrially fabricated shiny bright red PVC, along the horizontal axis of the building to unite its north and south façades. Fusing with, yet also delimiting itself from the architecture of the building, the long sweep of *Taratantara*, as the sculpture was named, defined a space within a space. Its external skin cast a brilliant red colour onto the walls of the Baltic, the edge of the long hollow form appearing to unite with the surrounding space. It produced the physical sensation that the building was turning in on itself.

Spatially, Kapoor saw the Turbine Hall as a rectangular box with a shelf in the middle, or as one continuous space. During the initial stages of planning his project, Kapoor's first instinct was to expand upon the language of the Baltic piece. He produced a maquette of the Hall – a plywood rectangle with one of the longest walls cut away, into which he inserted a hollow form that spanned its length. This form, which might also be made of fabric, would be attached to free-standing structures that mirrored the dimensions of the internal façades of the east and west ends, but at an angle that deliberately separated them from the architecture itself. Kapoor was intent on producing a form that would respond to the space of the Turbine Hall, but not be perceived as architecture. 'I almost never can think of a work without thinking of where it is,' Kapoor has commented, but on the other hand, 'there's a preoccupation in architecture that context determines what happens on site. That's bullshit. A good idea adapts itself to the site.'[5]

Kapoor's insistence on distinguishing between sculpture and architecture could appear nostalgic. It echoes, in some ways, Sol LeWitt's insistence in his 1967 'Paragraphs on Conceptual Art', that 'Architecture and three-dimensional art are of completely opposite natures.'[6] But, unlike LeWitt, Kapoor's desire to specify what architectural practise has to offer stems from his interest in its expressive potential. He is willing to borrow process from architecture and engineering, but sceptical about the extent to which those languages are capable of conveying meaning. Kapoor still wants his forms to project meaning, if not symbolic meaning.

To move beyond the language of the maquette, Kapoor began conversations in February with Cecil Balmond and his team of structural engineers at Arup. Balmond, a world-renowned expert in structural engineering, was sympathetic to Kapoor's methodology, as he does not regard the engineering process as inimical to meaning. In writing about him, the architect Rem Koolhaas has said: 'he has destabilized and even toppled a tradition of Cartesian stability – systems that had become ponderous and blatant . . . Instead of solidity and certainty, his structures express doubt, arbitrariness, mystery and even mysticism.'[7] Over the course of many months, the artist probed a diagram of the Turbine Hall. A diary of these images – hand and computer-generated models and drawings, are reproduced in the 'Towards Marsyas' section of this book. They document a process, the development of *Marsyas*, which, as with any architecturally scaled construction, exists only in the creative imagination of its planners until all its myriad components are independently realised. Artist and engineer both acknowledged that the materials and techniques used were as much a part of the content as the form itself. The scale of the project required sophisticated industrial materials and processes, including technical software that used specially adapted, non-linear, form-finding techniques to realise the final structure.

Using industrial materials and processes for Kapoor, then, is not a renunciation of associative content as it was for Donald Judd. Such an observation may appear ironic, when we are considering a sculpture that in its final form is made of 3,500 metres of fabric and 40 tonnes of high-strength structural steel, or, for that matter, the Turbine Hall itself. In the aftermath of Minimalism, numerous artists, including those of Kapoor's generation, grappled with the ways in which artists such as Judd attempted to expunge referential content from the work of art. Their autonomous objects were to be self-contained, constructed of industrial materials that no longer bore evidence of hand, its internal logic

5 Anish Kapoor in conversation with Donna De Salvo, June 2002

6 Sol LeWitt, 'Paragraphs on Conceptual Art', *Artforum*, 5 no.10 (June 1967): 79–83

7 Cecil Balmond, *Informal*, Prestel 2002, quoted in preface

determined through the repetition of existing forms and materials. Kapoor's project, however, is closer to those artists who were associated with Post-Minimalism. By the late 1960s and 1970s, Eva Hesse, Richard Serra and other artists, began to question Minimalism's supposed objectivity through an emphasis on processes that directly linked to the body.

There is an uncanny resemblance between the logic behind Kapoor's finished sculpture for the Turbine Hall, his *Taratantara*, and the computer-generated drawing of the square into a circle. In each instance, once the artist had decided upon certain parameters, set the terms, what followed was the result of a natural geometric progression. The terms for *Marsyas* are determined by its three circular steel rings, two positioned and attached to each end of the Hall, and one suspended above the platform of the bridge. What comes between is a 110-metre continuous span of a dark red seamed PVC fabric membrane held in place by fabric belts. The dynamic generated by these three rigid structures determines the overall language of the sculpture, a natural shift from the vertical to the horizontal and back to the vertical.

The title is a reference to Titian's painting, *The Flaying of Marsyas* (1575–6), in which the satyr Marsyas, in a reference to Greek mythology, was flayed alive by the God Apollo. There is an inevitable connection to be drawn between the stretched red membrane of Kapoor's *Marsyas* and the flayed skin of Titian's masterpiece. There was a moment when the artist explored the use of silver reflective fabric for this work, but his strongest inclination was towards red. Kapoor has long exploited colour for its optical quality and its associative potential, and for some time red has been part of his language, though he has also worked with other primary colours.

Kapoor had imagined the Turbine Hall as three distinct spaces to be linked by a single-span dark red membrane. One ring of the sculpture would be vertically positioned at its west end and at the very top of the ramp leading visitors down into the space of the hall. A second would be similarly positioned at the east end, in the area once occupied by the projects of Bourgeois and Muñoz. The placement of these two rings would establish the overall span of the sculpture, and also impact upon what could happen with the bridge, which continued to hold symbolic meaning for Kapoor.

Although the insertion of the bridge had solved a functional problem for the architects – moving people from one level to the other and functioning as viewing platform – the artist found it problematic. He felt the bridge to be a place without destination, and this was a circumstance he wanted to change. He chose to undermine this architectural element. He used architecture and engineering to contend with scale, and the language of sculpture to subvert the bridge. He explored a number of options. In one, a bean-like shape would occupy the bridge and completely engulf it to become a structure within the structure of the Turbine Hall. In another, he would divide the single and elongated hollow suggested by *Taratantara* into two funnel-like sections that would rest on the floor of the Turbine Hall and either side of the bridge. Their width would be derived from that of the platform, length from that of the end wall to the bridge, and height from the base of the platform to the ceiling. These structures would frame the bridge and transform what had once been a transitory space into a destination, with views now into the sculpture. Though neither option was pursued, the ideas re-energised the discussion of the problem and potential of the bridge.

Was it possible, then, to find within the single expanse of the sculpture a structure that could also take on the bridge, and what effect would this have upon its overall form? A third ring would be added to the sculpture and also positioned on the bridge and held in place through the tension exerted by the two opposing rings. This ring would stretch the fabric to create huge sweeping arches that reached from the floor of the Turbine Hall to that of the bridge. It might also, like the bean-like structure, be closed and only accessed by the stairs connecting the platform of the bridge with the ground floor.

Coming into contact with the bridge, the sculpture now seemed as if it were coming back to earth, and this

signalled a very different direction in the project, though one that has always been a fundamental concern in Kapoor's work, with its distinct relationship to the human figure. Rising up from the bridge, these forms could now touch the ground in a way that alluded to the figurative. Perceptually they had the potential to provoke a profound physical response in the viewer. But what would happen if that same form were lifted above the platform? And what would this add to the meaning of the sculpture?

There are several moments in the experience of *Marsyas* in which the viewer comes close enough to it to have physical contact. At specific points – at the ground floor west entrance and the east end of the Turbine Hall, where the vertical rings are jammed into the building – the sculpture is earth-bound. It is here that a monochromatic field of dark red confronts you, and you confront it as well as the void that is at the centre of its hollow, funnel-like arm. Standing on the other façade of this structure, there is an instinctive urge to trace the trajectory of that arm as it soars up and towards the bridge, the resulting vertigo plunging the body into a kind of free fall. However, the most corporeal associations may not reside in the language of these vertical rings, whose height reflects that of the Turbine Hall, but are to be found within the single horizontal ring hovering above the bridge.

Unlike the two vertical rings, the height of the horizontal ring – roughly 2.5 metres, introduces human scale. At this height, the ring hangs above us and wedges the body between an edge of steel and the ground beneath. There are two passages into this area. One is the north entrance of the building, the other a set of stairs linking the ground and second floors, and whatever one you chose to take you are moved into something that feels deeply interior, and even more bodily. 'I work with red,' he has said, 'because it is the colour of the physical, of the earthly, of the bodily. I want to make body into sky. This is a fundamental transformation and somewhat mysterious.'[8] As light passes through the membrane, the seams are more apparent, more like muscle and tissue, the dark red more visceral. It is also here that the steel is no longer supported by the rigidity of the building, but, almost unbelievably, by tension of the membrane.

Implicit in the journey through this piece is narrative, but one comprised of discrete encounters. Some may claim that the centre to this work is its horizontal ring, but the sculpture is not symmetrical. If there is a centre to be located, it is only to be reached by measuring and finding the Hall's mid-point, which is not the horizontal ring. If anything, our experience is constantly disrupted as the work keeps challenging you to make sense of it, to find out where you are, its shape continues to morph. What holds it together is what Kapoor calls its 'connecting tissue'.

Marsyas combines two distinct languages. The framework of welded steel rings is a nod to traditional sculpture. The plastic-coated membrane is something else, a contemporary geometrical formulation that is much more complex. The membrane fabrication would be inconceivable without digital technology and has been greatly influenced through the use of form-finding software. This type of software is capable of going beyond parallels with nature, to achieve previously unseen forms. The structural behaviour of the membrane is simulated under stress using computer-modelling techniques and the templates used to pattern its surface are also generated by computer.

Many years ago, Kapoor made the statement, 'I don't wish to make sculpture about form . . . I wish to make sculpture about belief, or about passion, about experience that is outside of material concern.'[9] This raises fundamental questions about the creation of meaning. Kapoor has evolved a lexicon of forms in his sculpture, returning to some over and over again, integers in some larger whole. These tend to be simple and elemental, forms he feels he knows because they already exist. Clearly, some of the thinking behind his objects has been influenced by his notions of Hinduism and mysticism, and a belief that there exist certain kinds of objects that seem to have made themselves.

8 Anish Kapoor in conversation with Donna De Salvo, June 2002

9 *Objects and Sculpture*, exh. cat. Institute of Contemporary Art, London, and Arnolfini Gallery, Bristol 1981, p. 20

Within the making of his work, and especially *Marsyas*, there is also recognition of the empirical, of the language of physics, mathematics, and engineering. Circles, squares, and fractal patterns are elements of a visual language that can mean different things in different disciplines, but which can also stand firm in their openness. It is within the capacity of form to be elastic, to be in a state of becoming, to keep us in a state of free fall.

Over the course of many months, this project has existed primarily at the level of drawings and models, modes of representation that have left us with a mental picture of something whole. That is a reality with one set of meanings, however, while the completed sculpture has another. Despite the intimate encounter possible within aspects of this work and the sensual and corporeal associations that are to be evoked by its blood-red 'skin', it is nevertheless impossible to comprehend the whole. This is fundamental to the work. There are multiple views to be experienced, but each is a partial one.

This is a direct attribute of the Sublime, something that was anathema to the more concrete and literal approach with which Judd was working. Kapoor is closer to Barnett Newman, an artist whose influence he readily acknowledges. Newman expanded upon the romantic traditions of the nineteenth century, using titles to link his abstractions with the natural world of *Tundra*, or the spiritual world of *The Word*. His notion of the Sublime was also very much one of the post-war era, affected as it was by the terror of what became known as the atomic age and the incomprehensible reality it thrust upon the world.

It is impossible to comprehend *Marsyas* as a whole, this is a given, but what does this mean? There are inevitable comparisons to be drawn and explored between it and the work of the eighteenth-century architect Etienne-Louise Boulle, who envisioned buildings so vast that they could never be constructed, or Robert Smithson's *Spiral Jetty*, or Richard Serra's *Torqued Ellipses*, the latter also using computers in its production. But perhaps there is also something of Eva Hesse here too – her use of synthetic resins, which she used to produce forms that infiltrated space in a new way, challenging the rigidity of sculpture.

To experience *Marsyas* it is necessary to walk its length, pass under it, over it, and through it. In doing so, we discover that what unnerves us most about this work is not just its size, but its twisting, asymmetrical form. This is especially the case at the east end of the Hall, where the sculpture terminates in a perfect circle, a classical moment that is then belied by the peculiar form the membrane assumes, which is anything but classical. A computer can only do what we program it to do, but this does not ensure comprehensibility. We are left with many unanswered questions, not least of which is whether the subject of the title of this work is the sculpture or ourselves.

In naming the work *Marsyas*, in choosing to use a blood-red colour, in producing a form that, while abstract, conjures images of the body, Kapoor invites inevitable comparisons with our own humanity. It would seem that the placement of such an object within the industrial milieu of the Turbine Hall would humanise the space, but there is something uncanny about this sculpture. This may be a circumstance of scale, but perhaps *Marsyas* is also an embodiment of forms both recognisable, *and* terrifyingly unfamiliar.

Anish Kapoor's sculpture could not have come into existence without the benefit of late twentieth-century technology. Nor could something of such massive scale have been achieved without the expertise of professionals with highly specialised technical knowledge and equipment. Situated within the disembowelled Turbine Hall, this collision of human imagination and seemingly limitless technological possibility may be what could be called a new Sublime, a technological Sublime. Whatever one chooses to call it, the experience Kapoor's *Marsyas* invokes is one in which our private reveries and fears are played out against the backdrop of an unfathomable synthetic landscape where we stubbornly struggle to hold onto any sense of a whole.

Marsyas

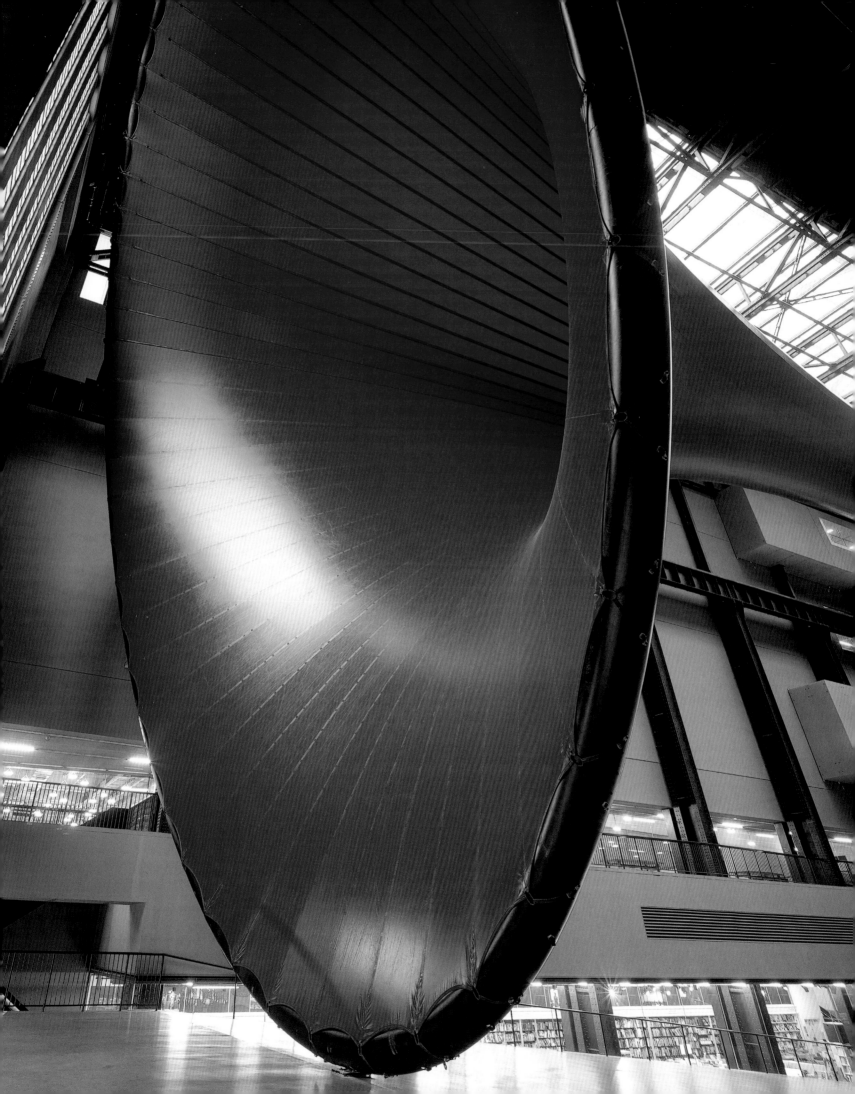

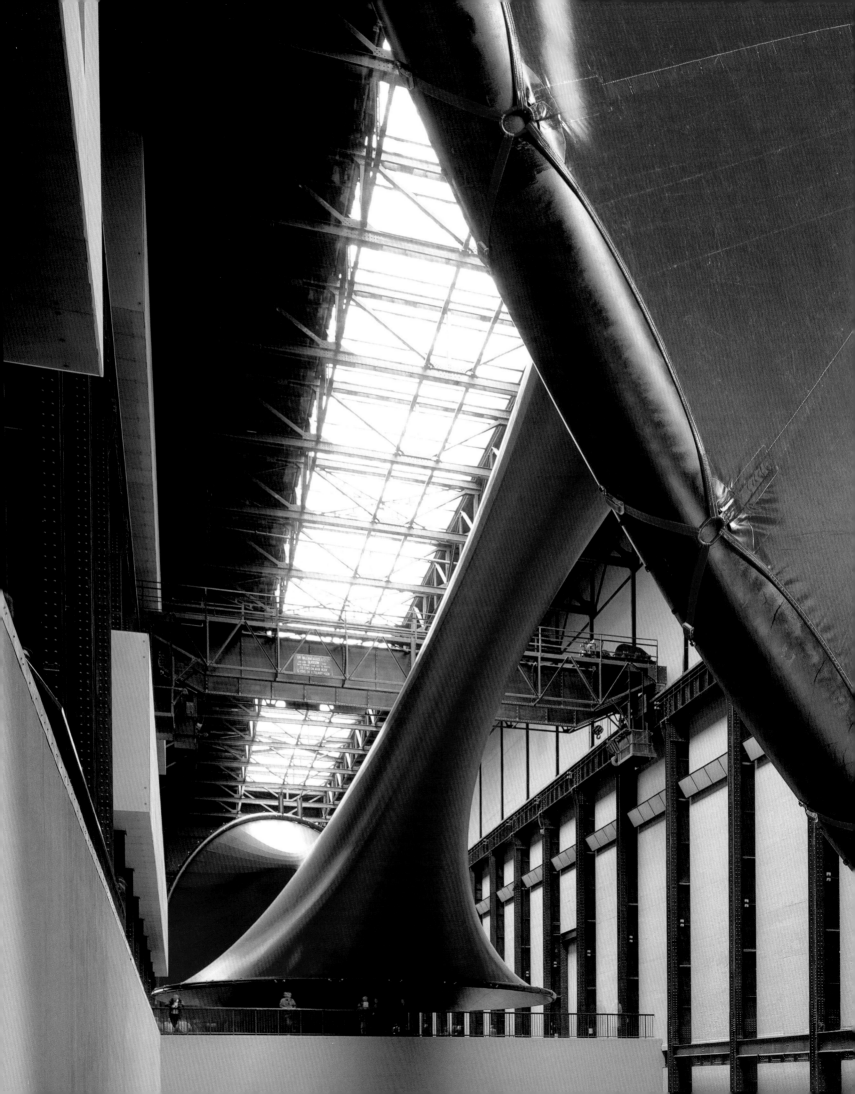

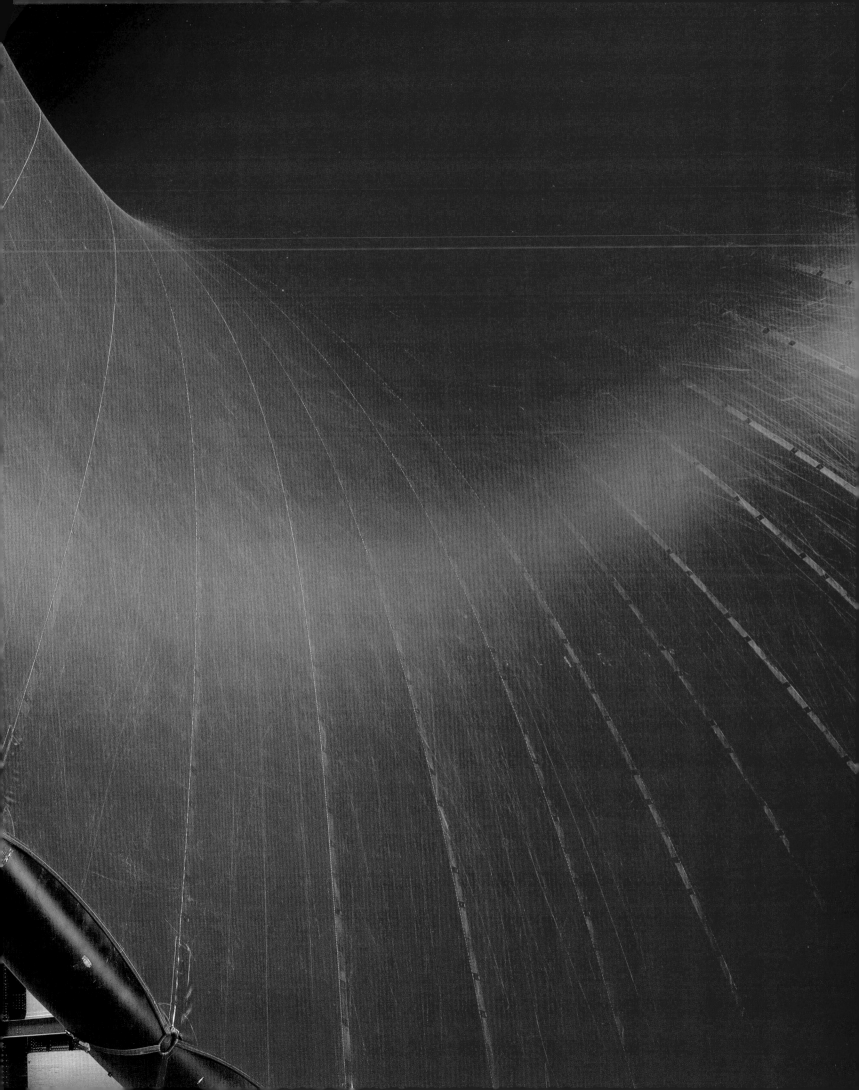

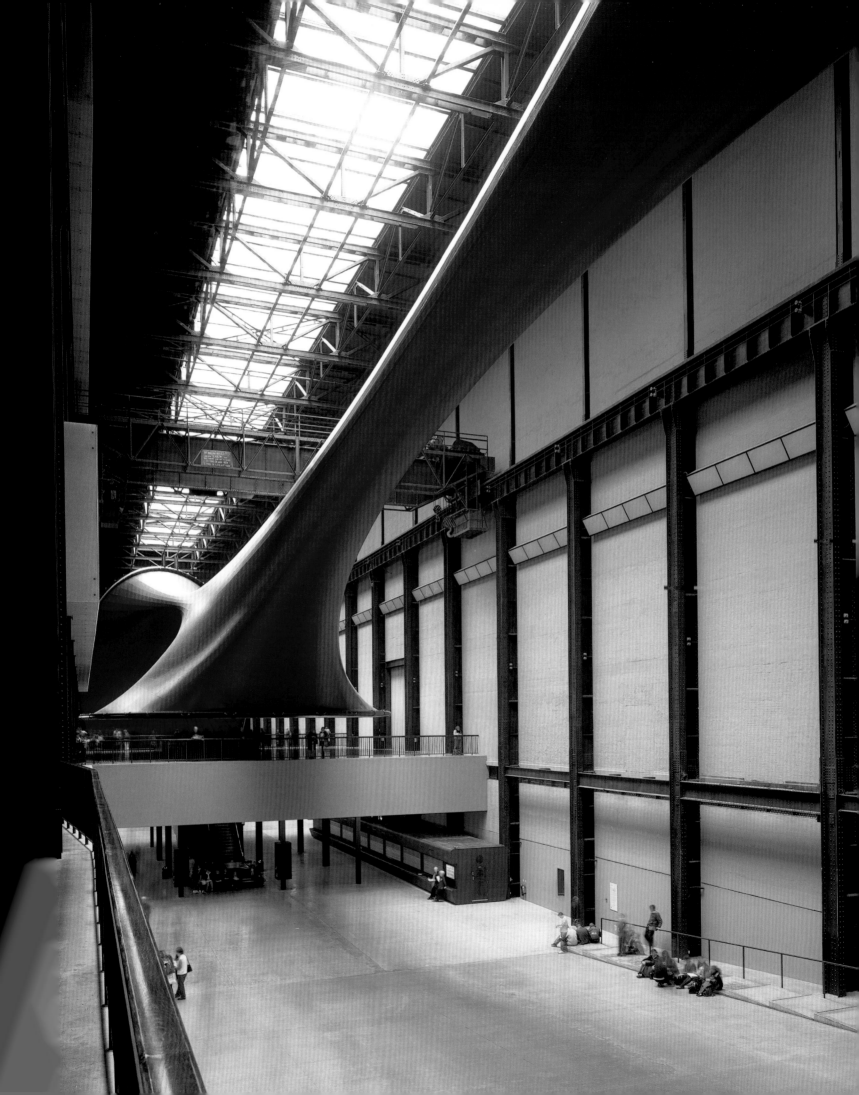

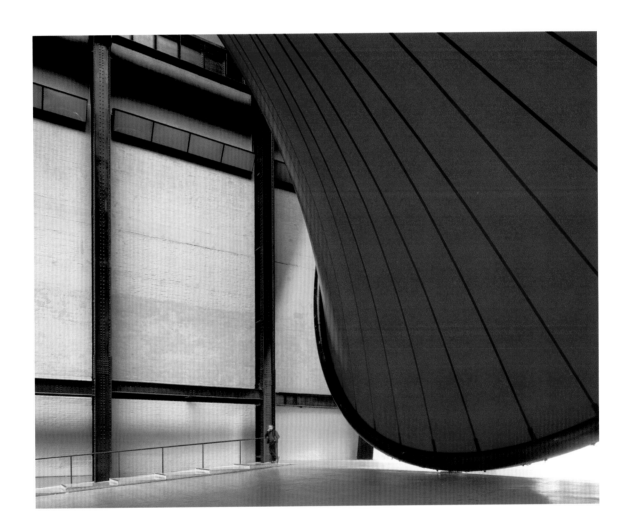

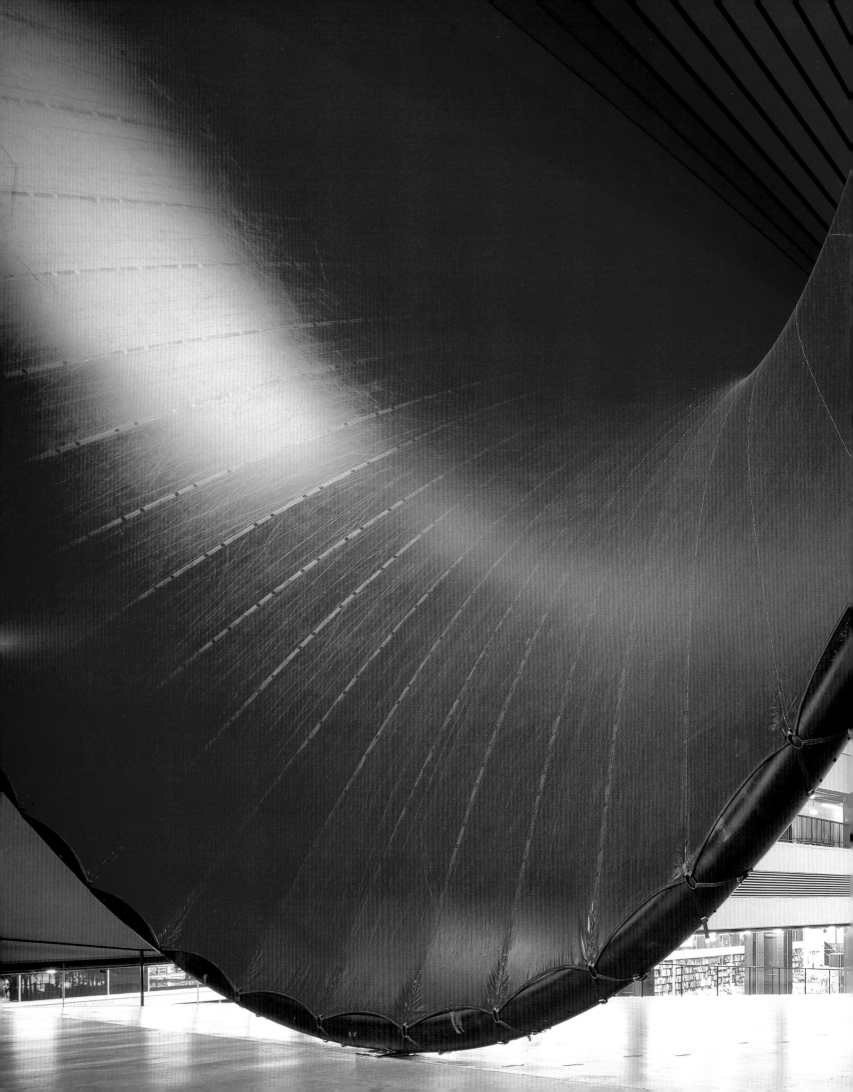

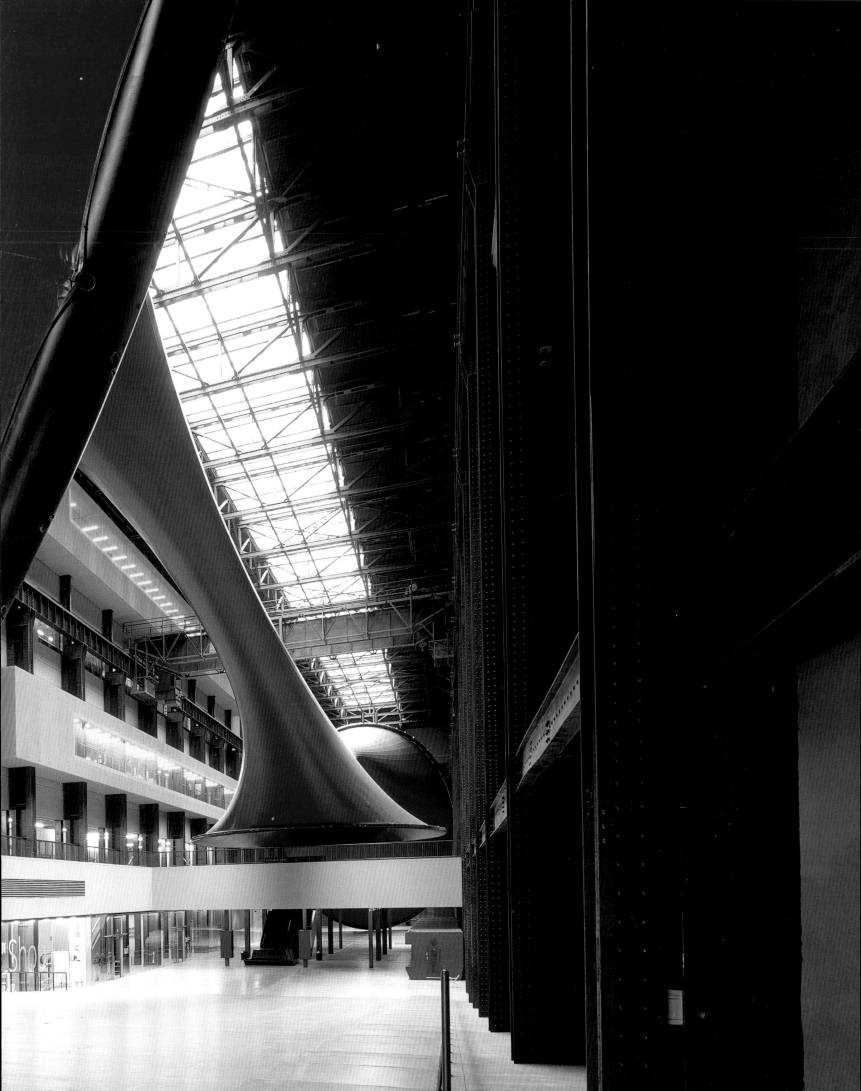

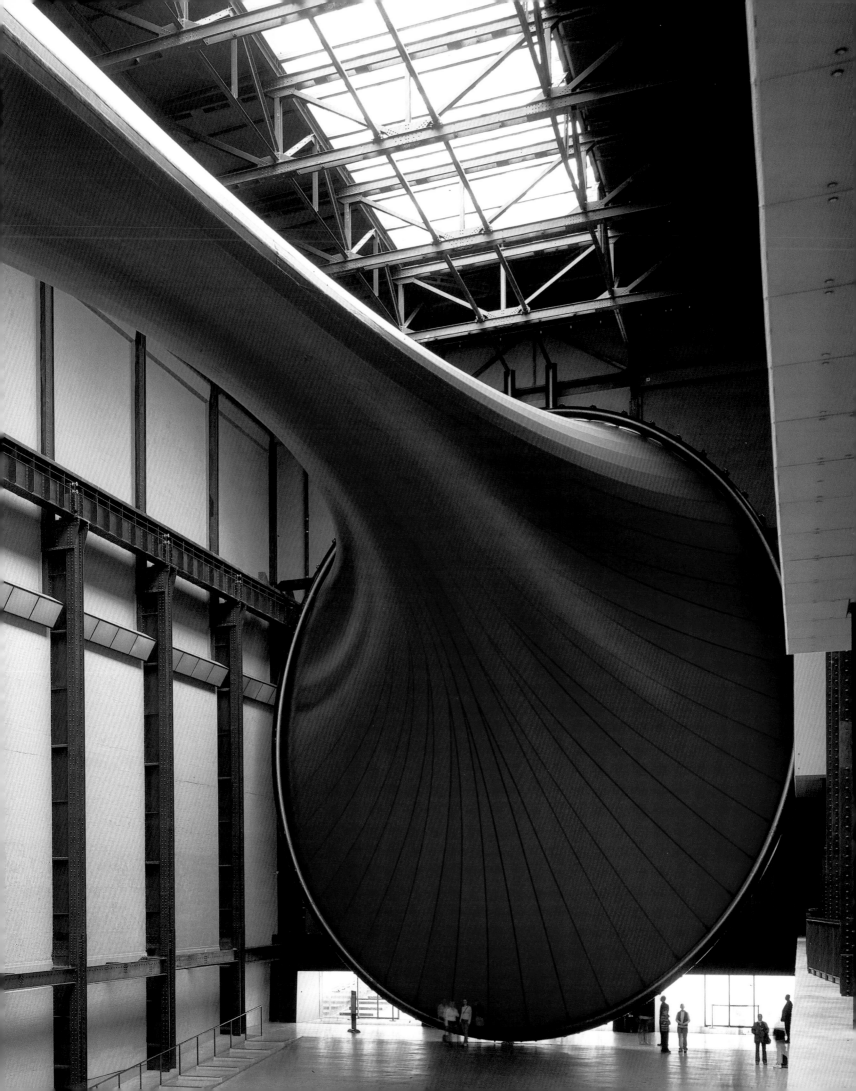

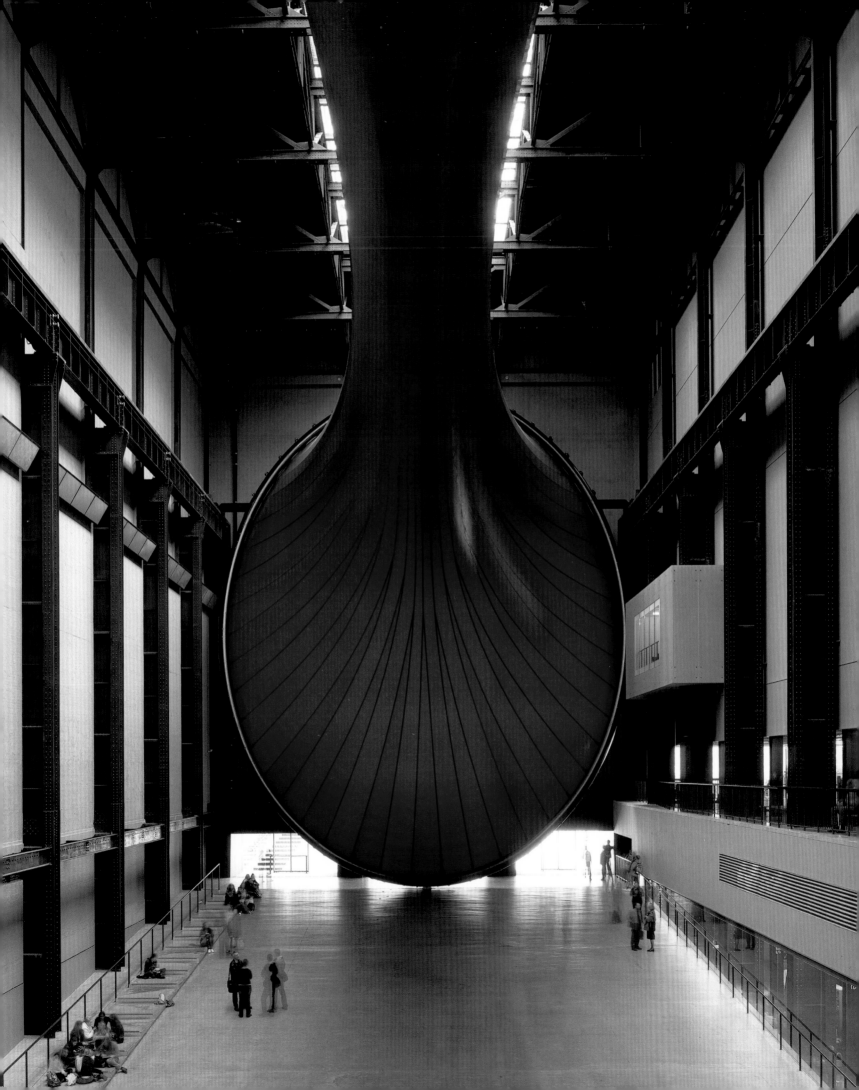

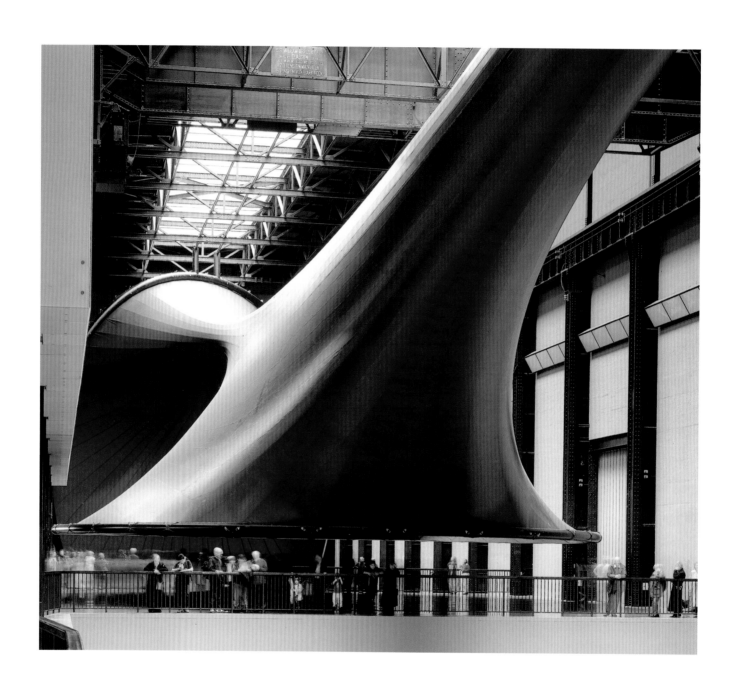

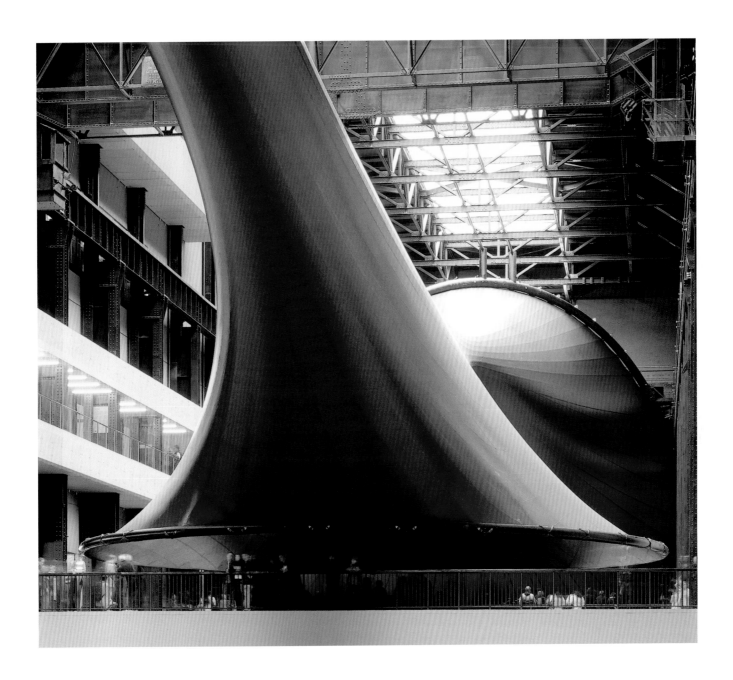

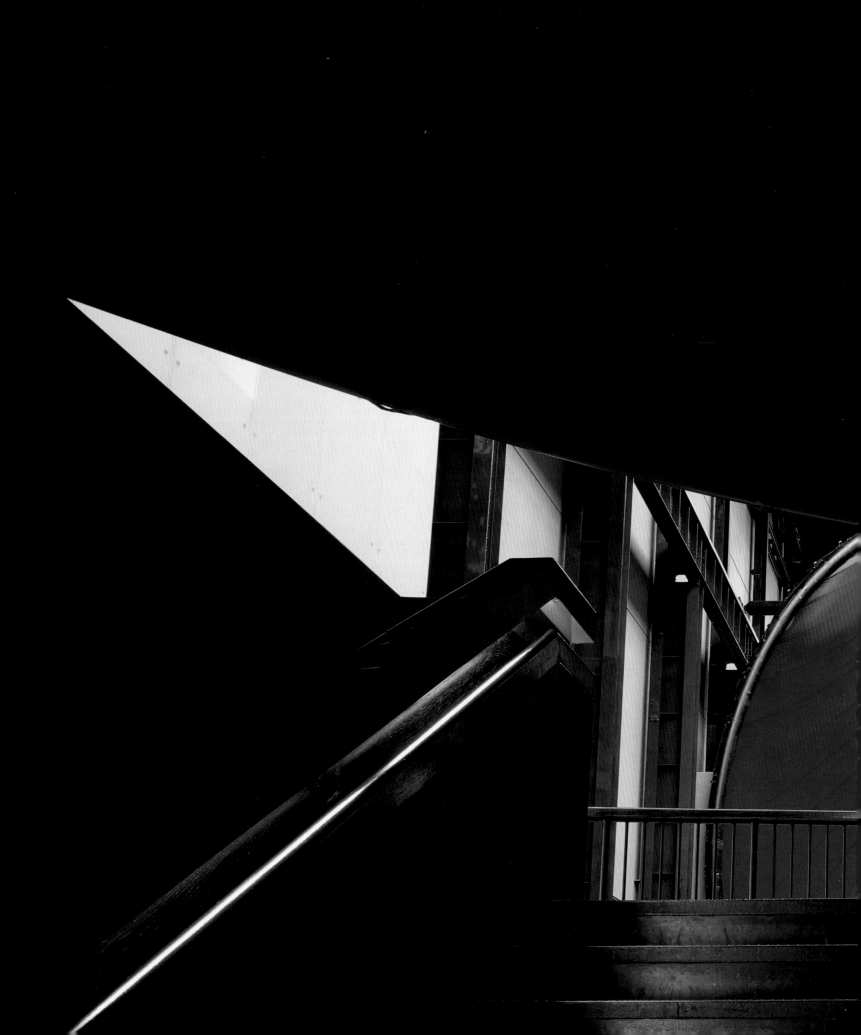

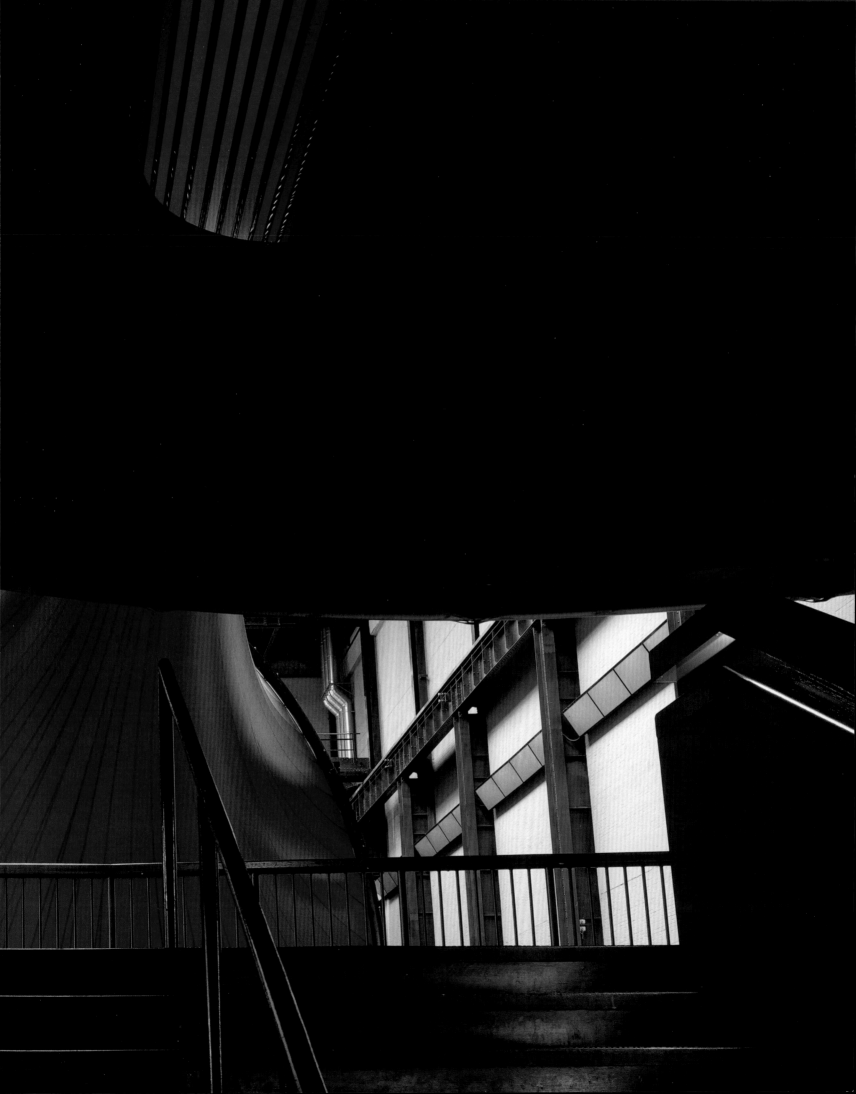

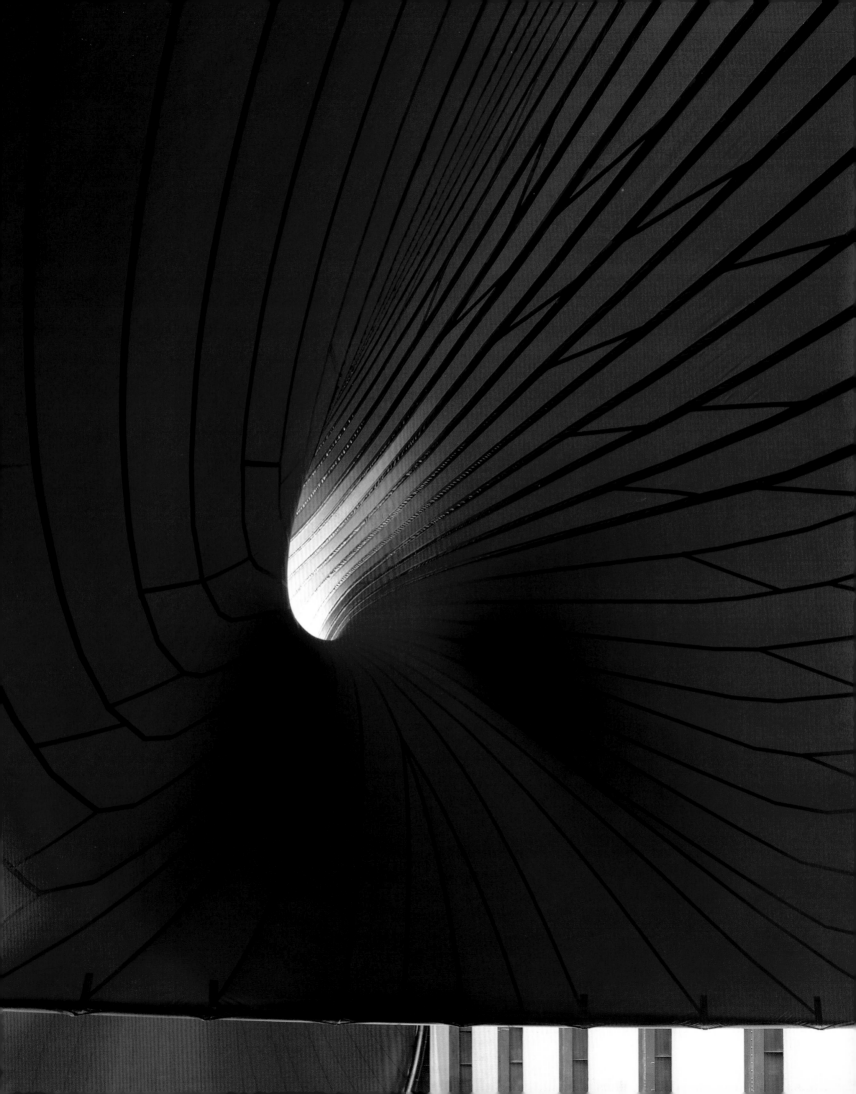

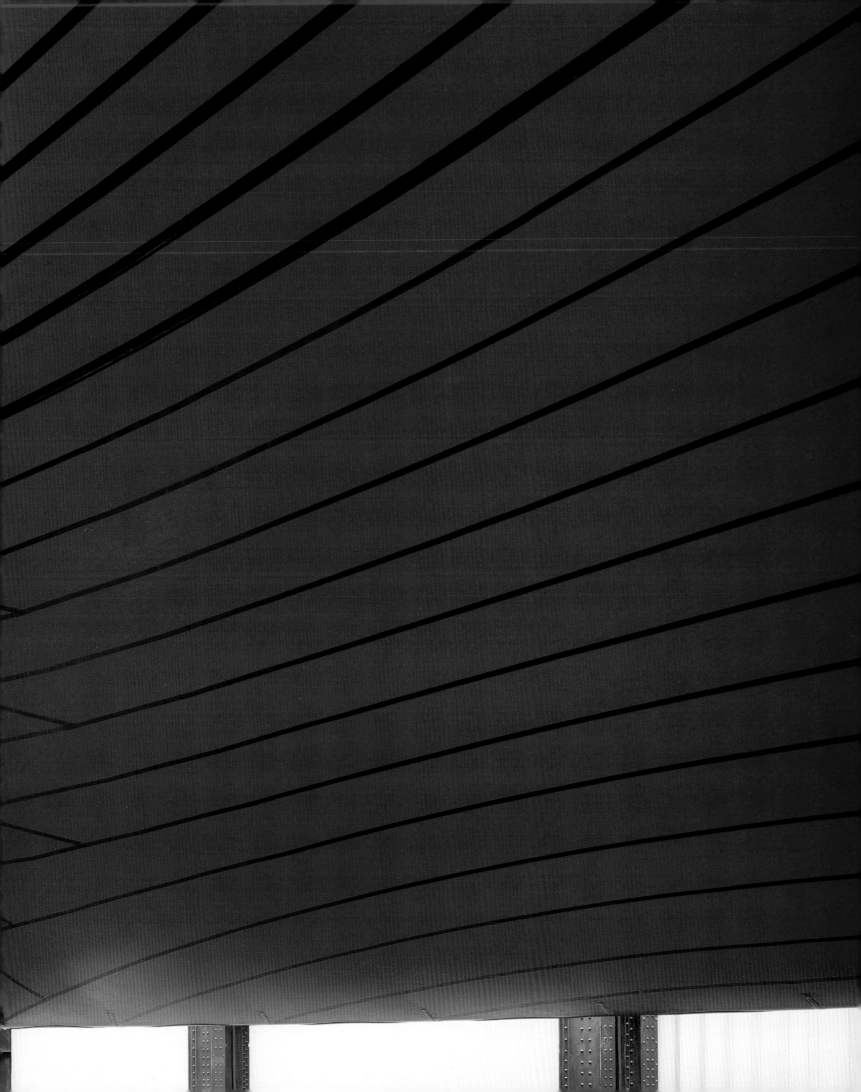

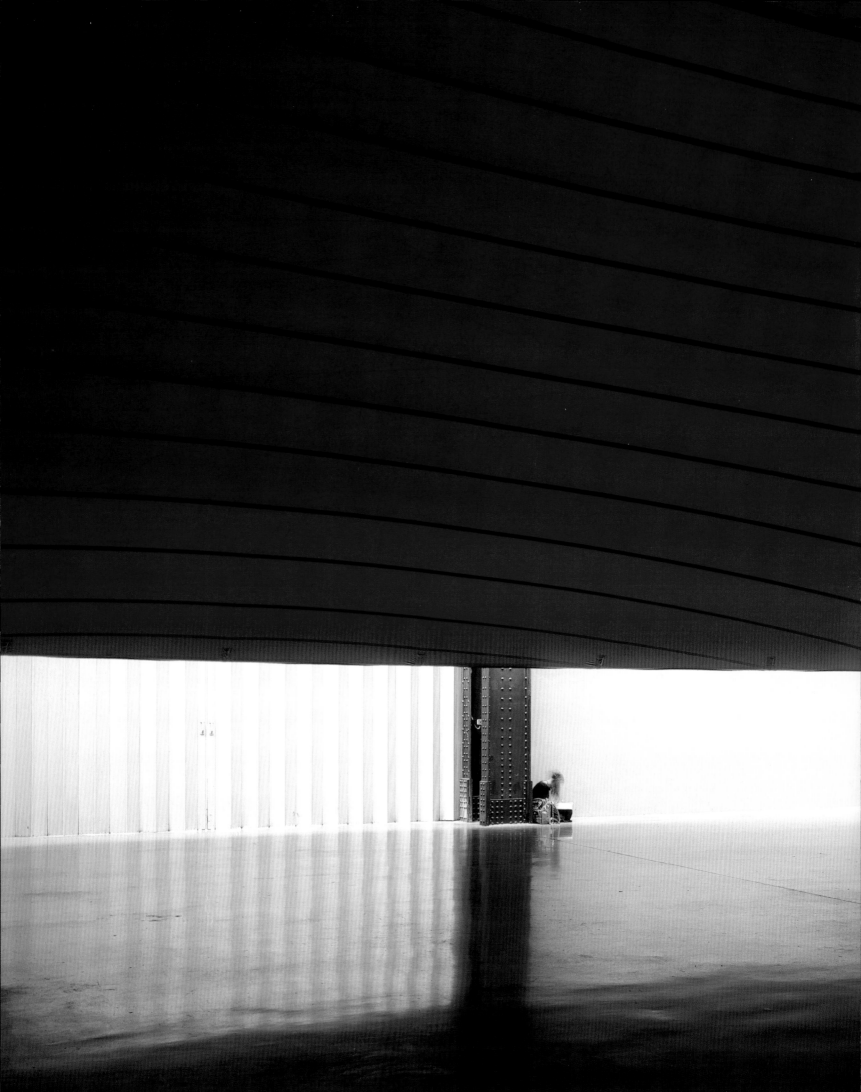

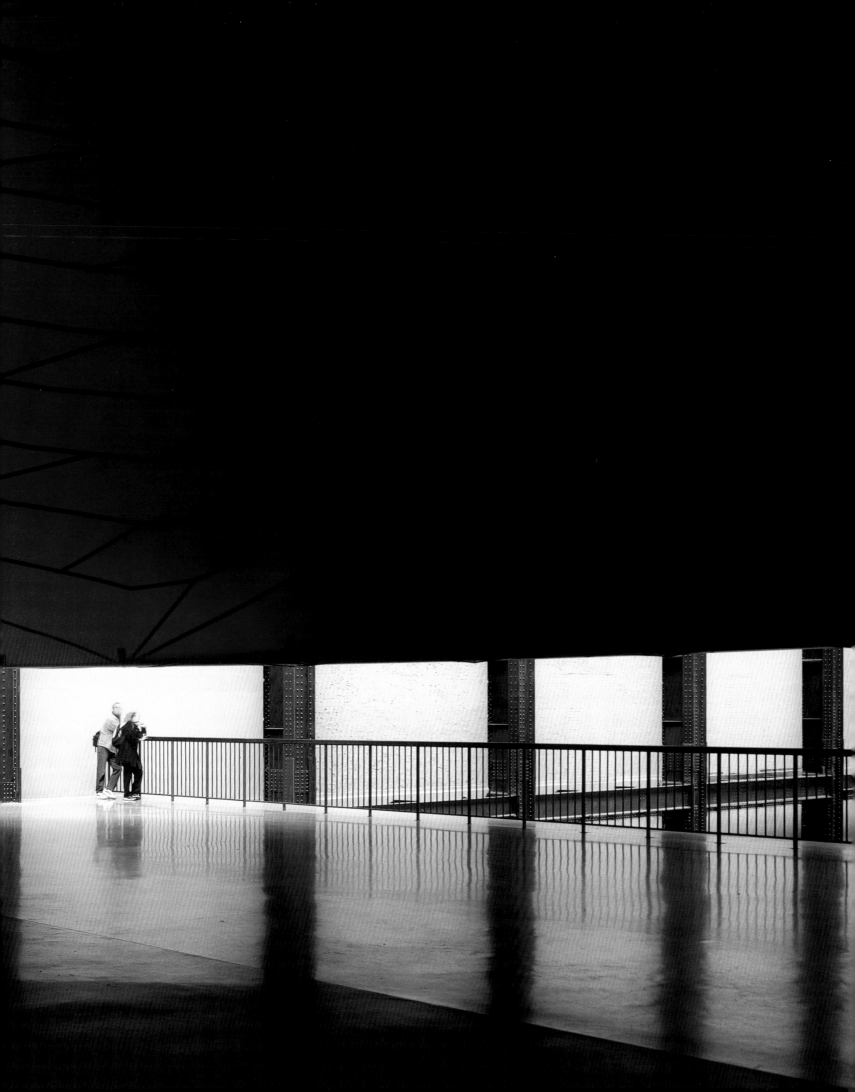

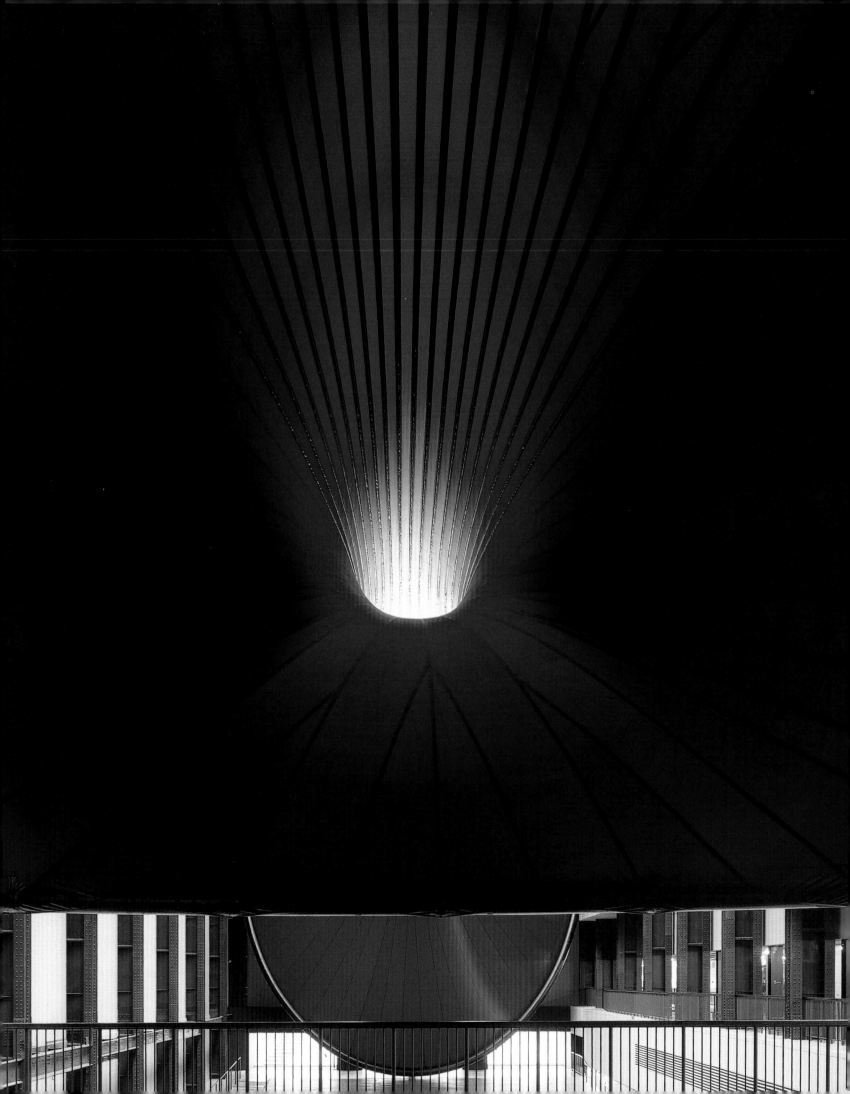

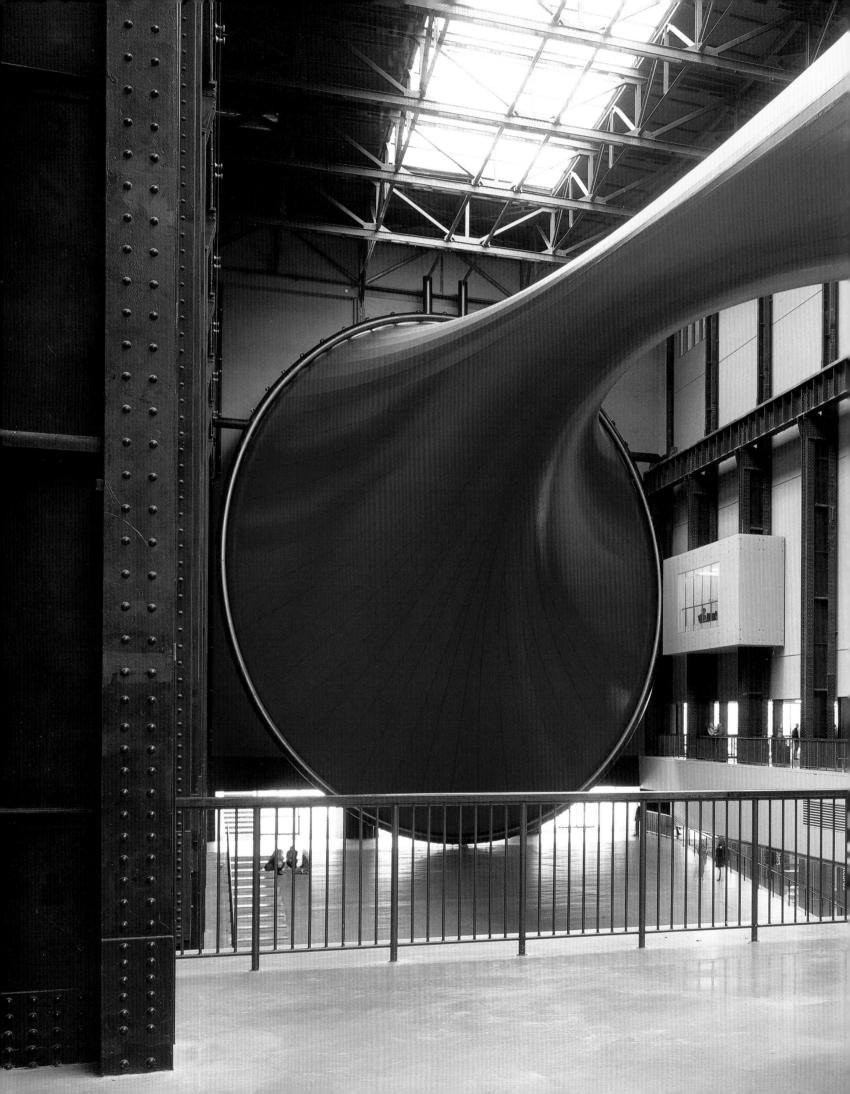

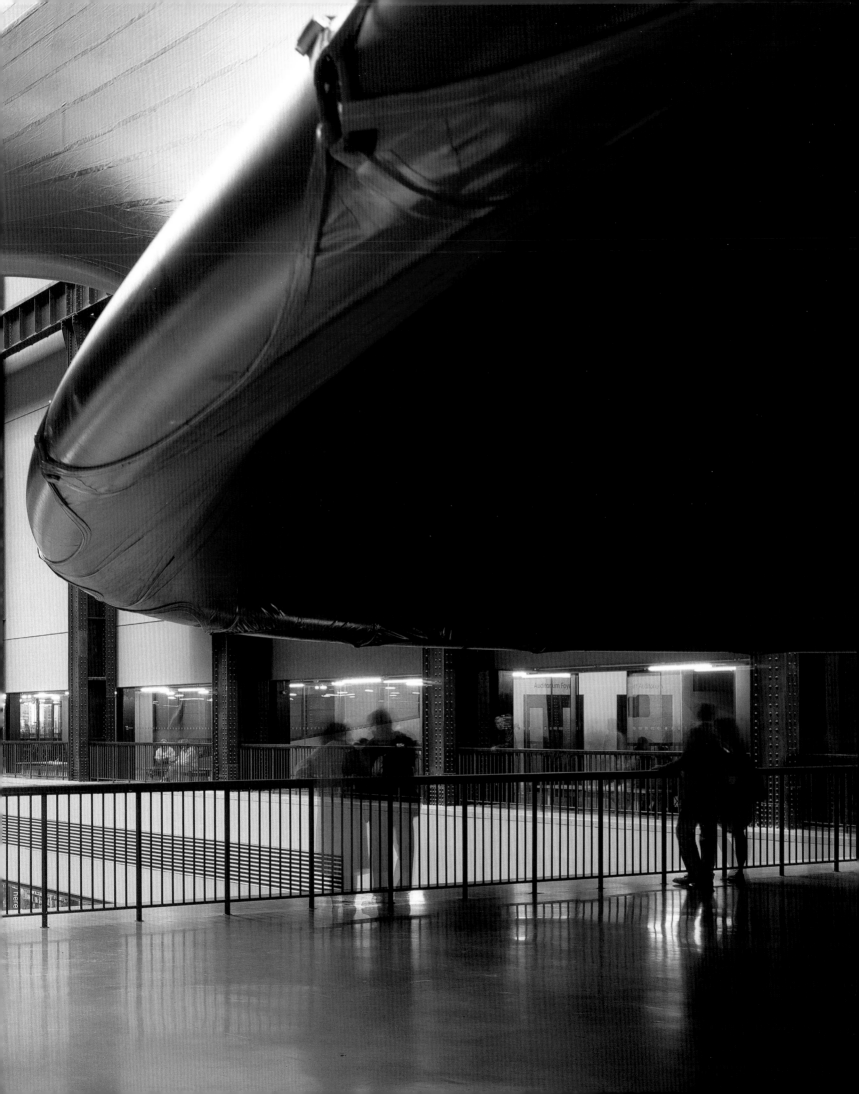

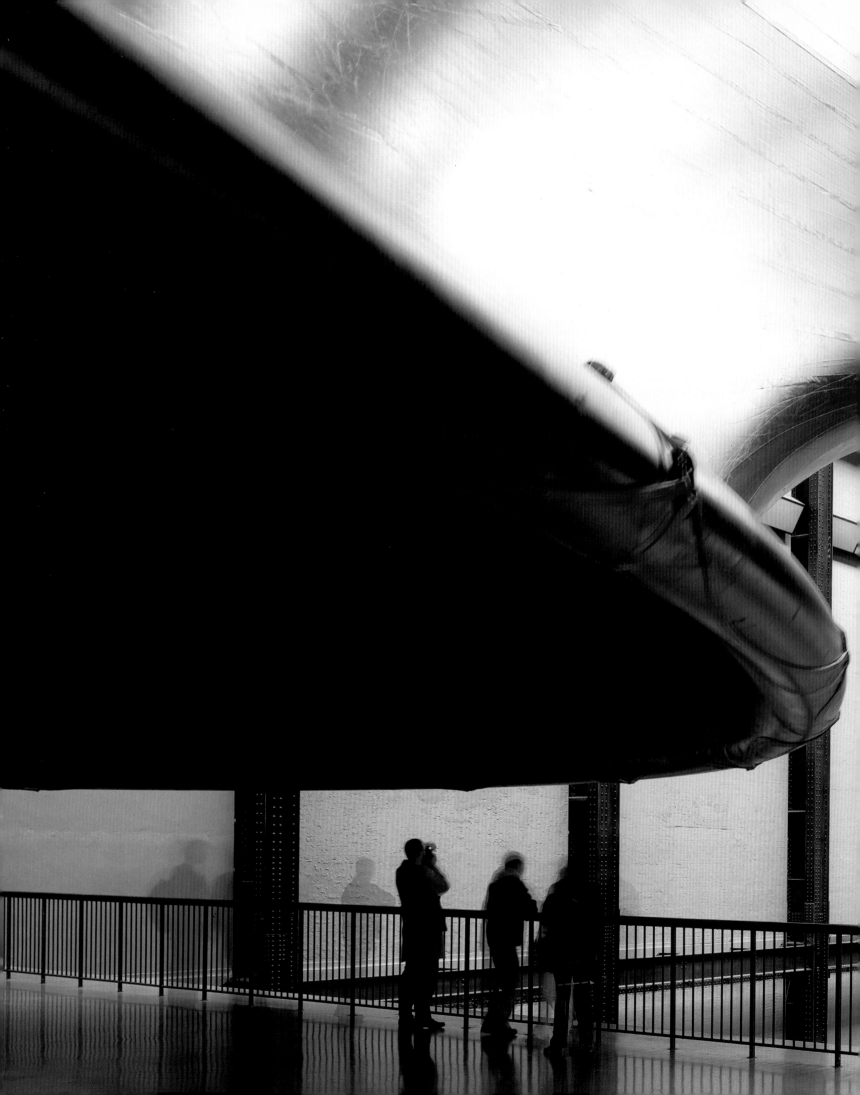

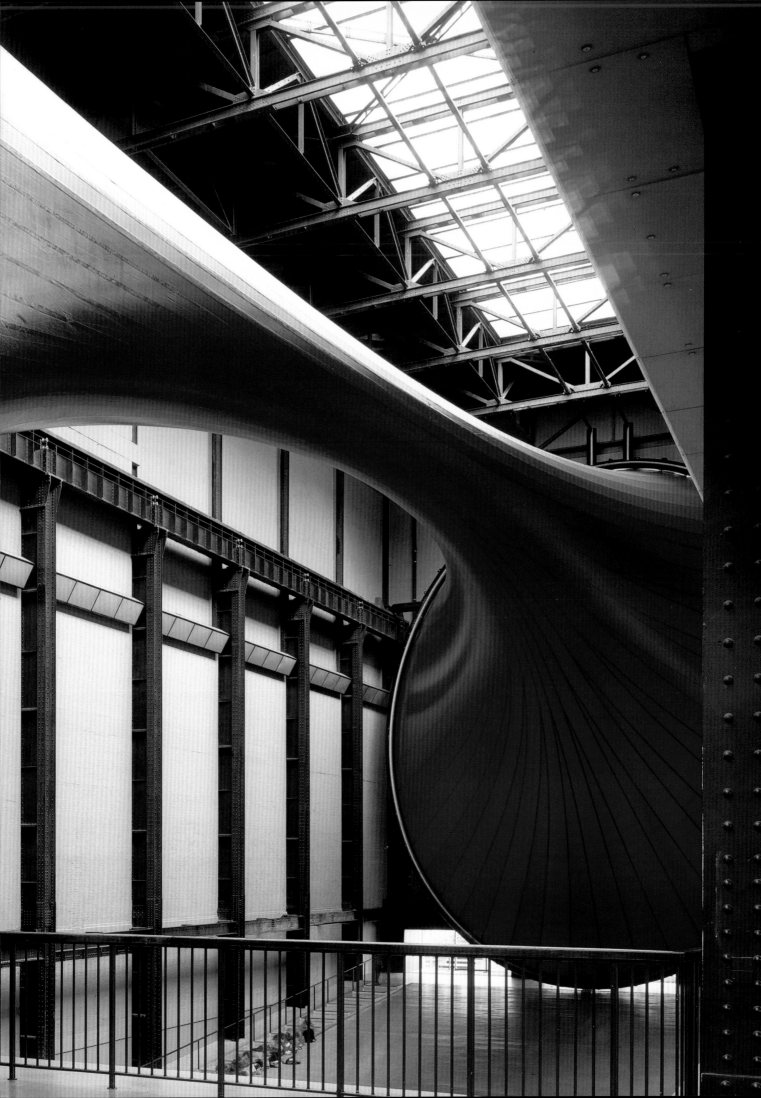

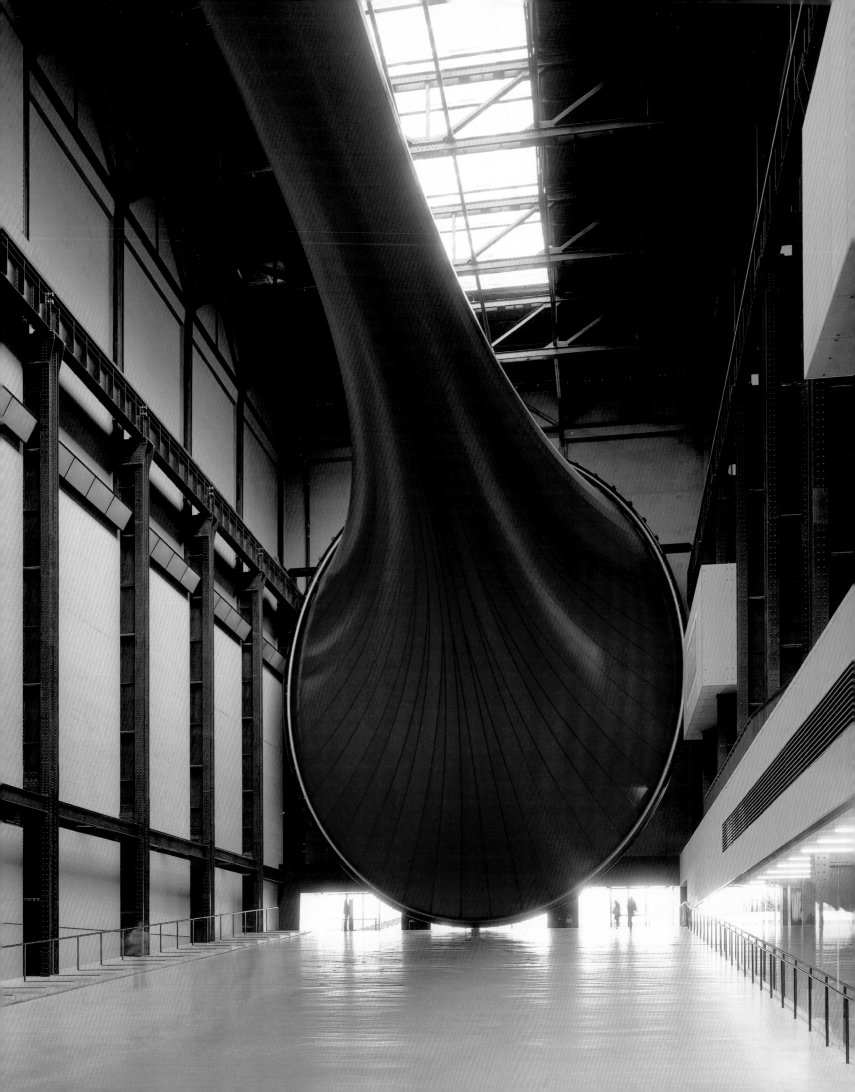

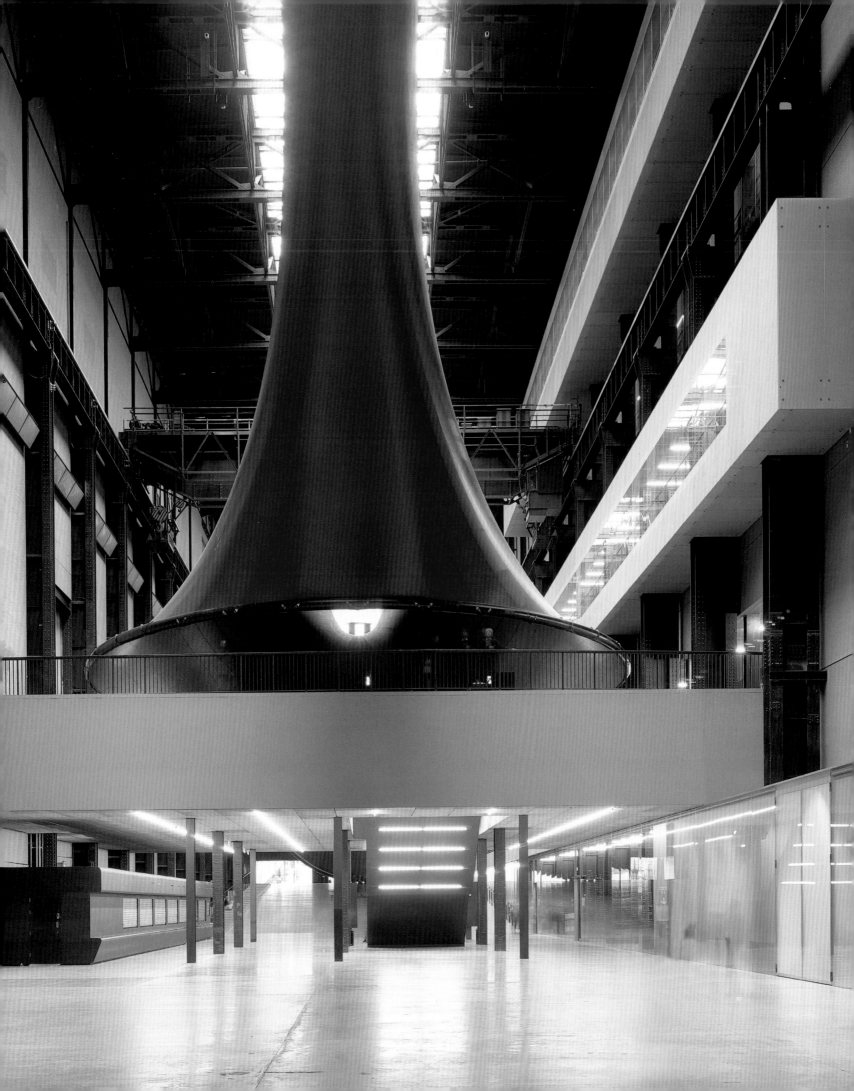

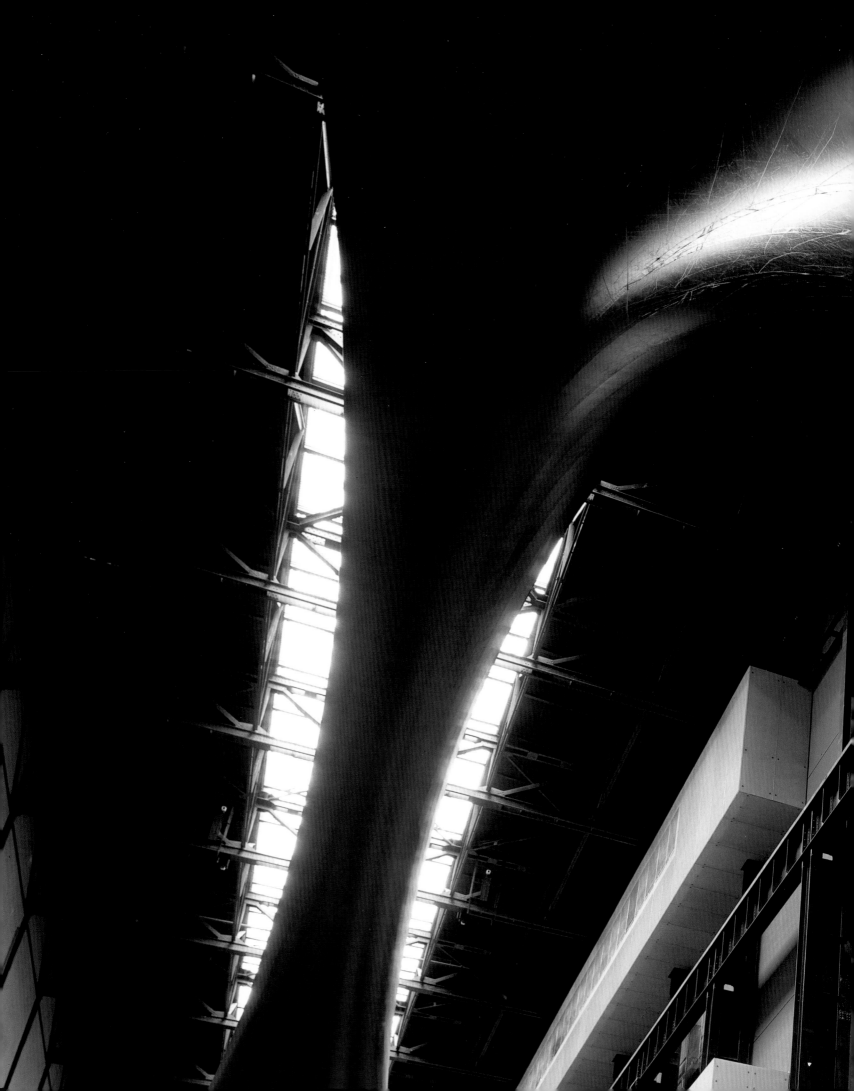

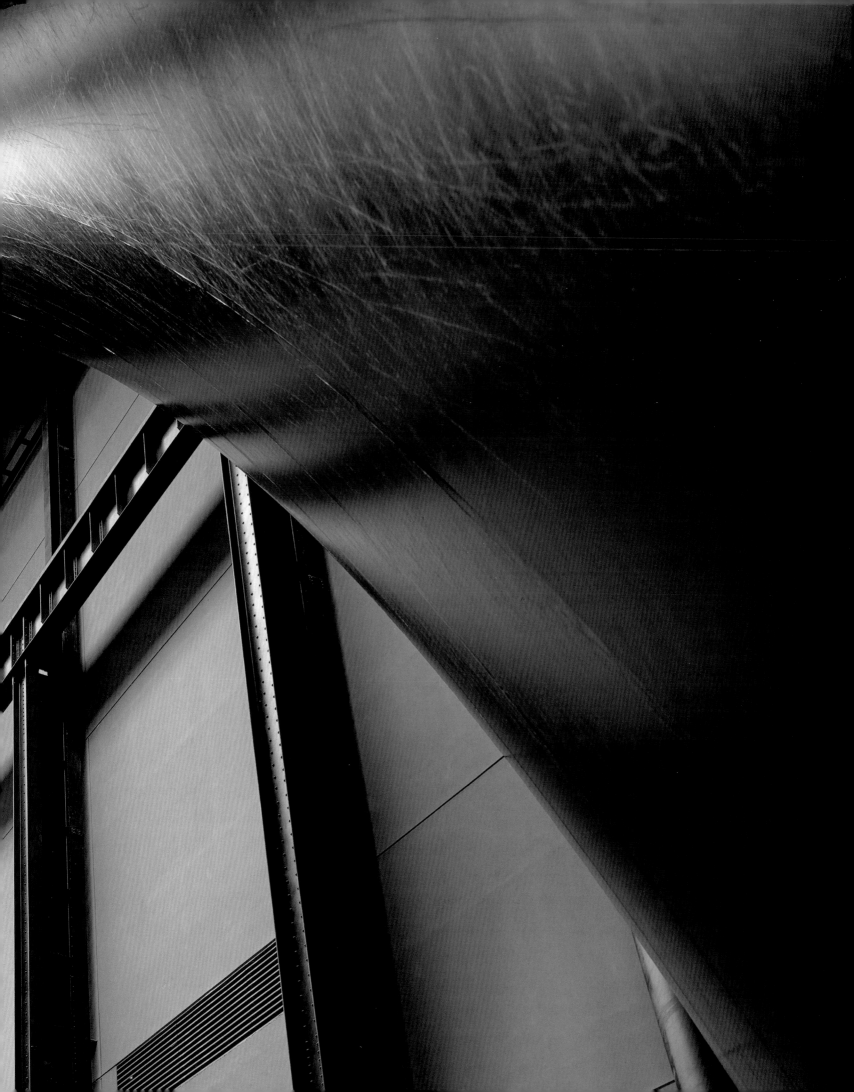

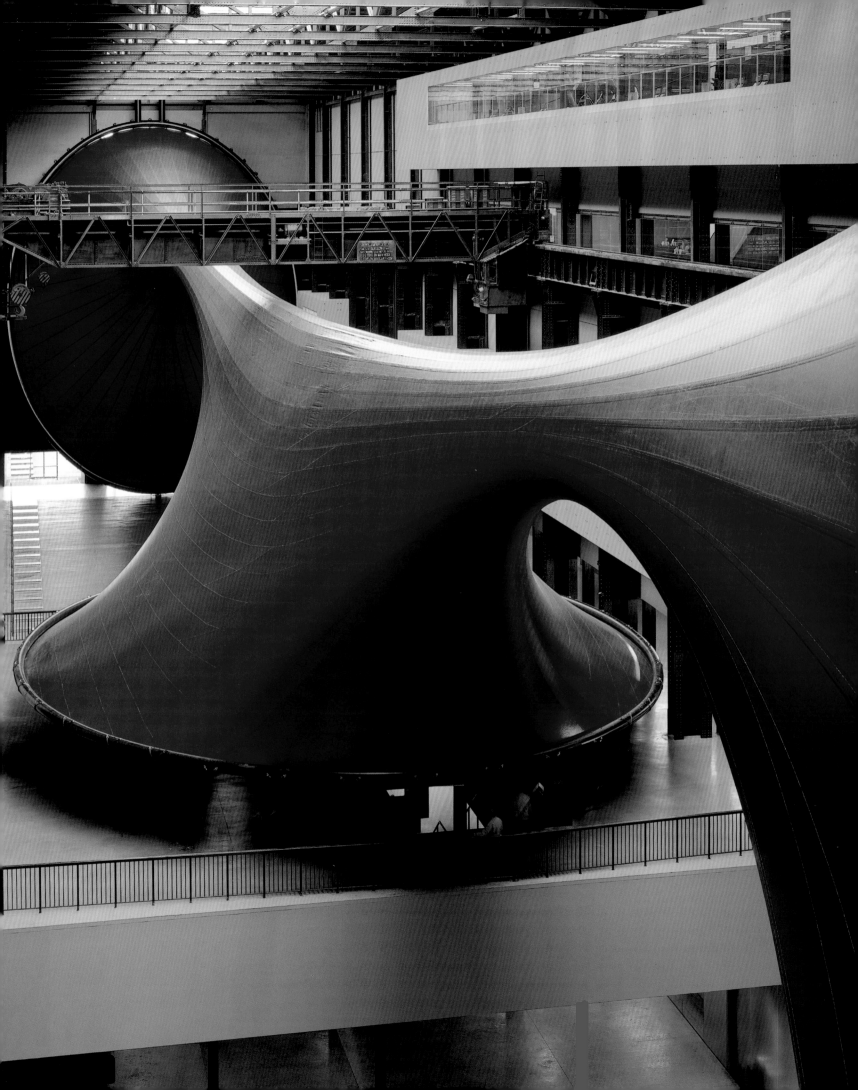

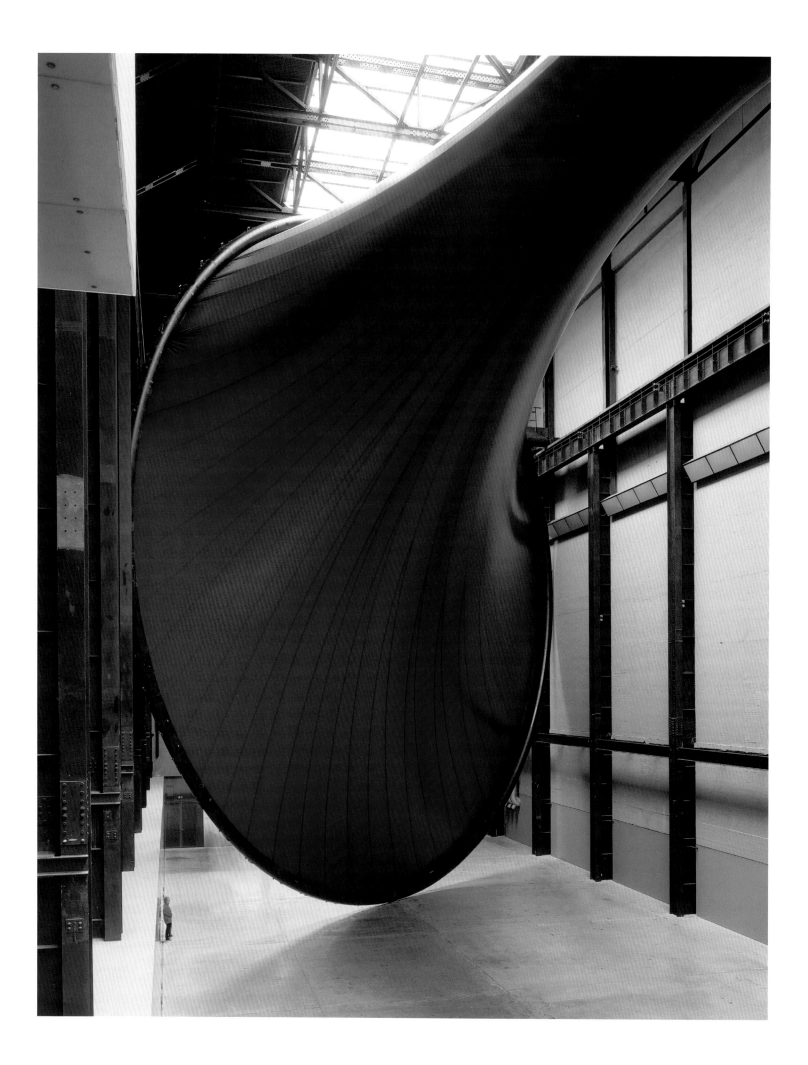

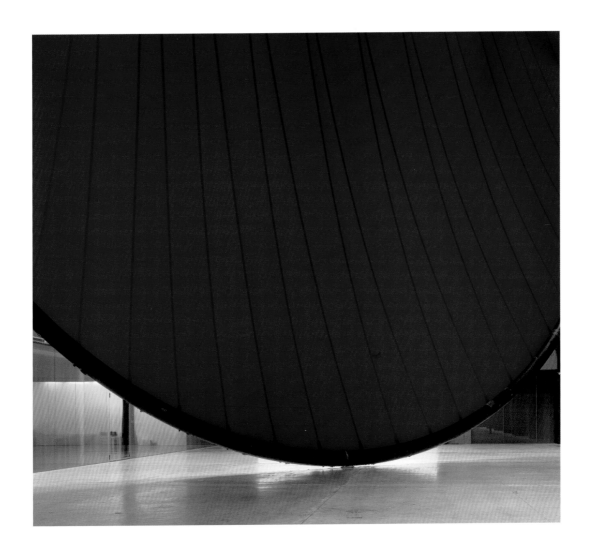

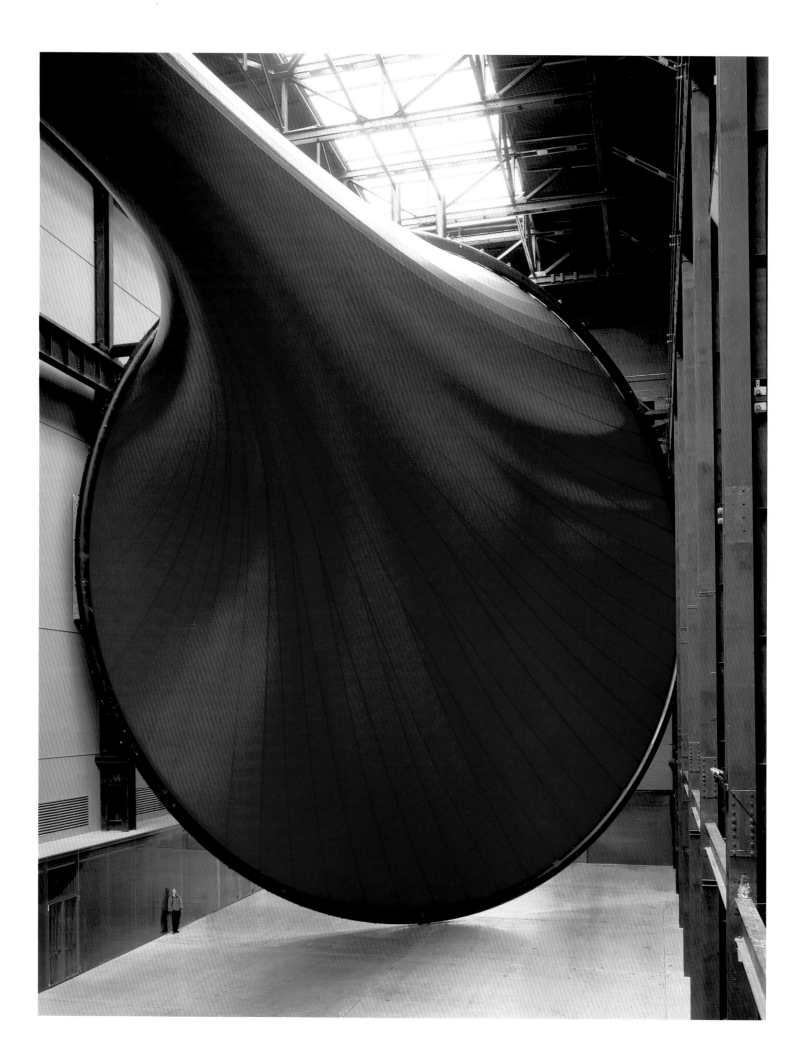

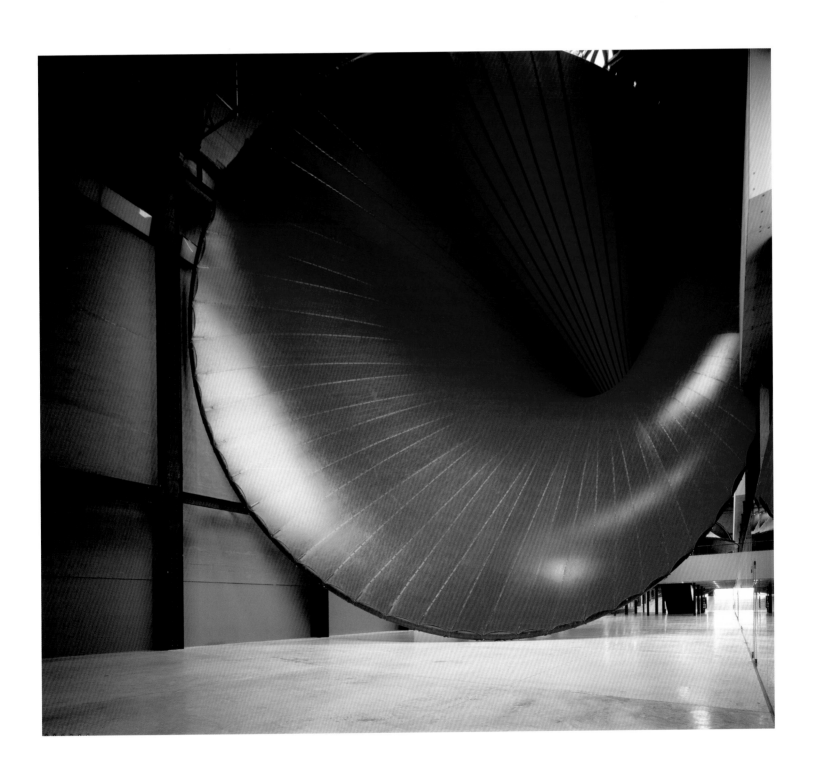

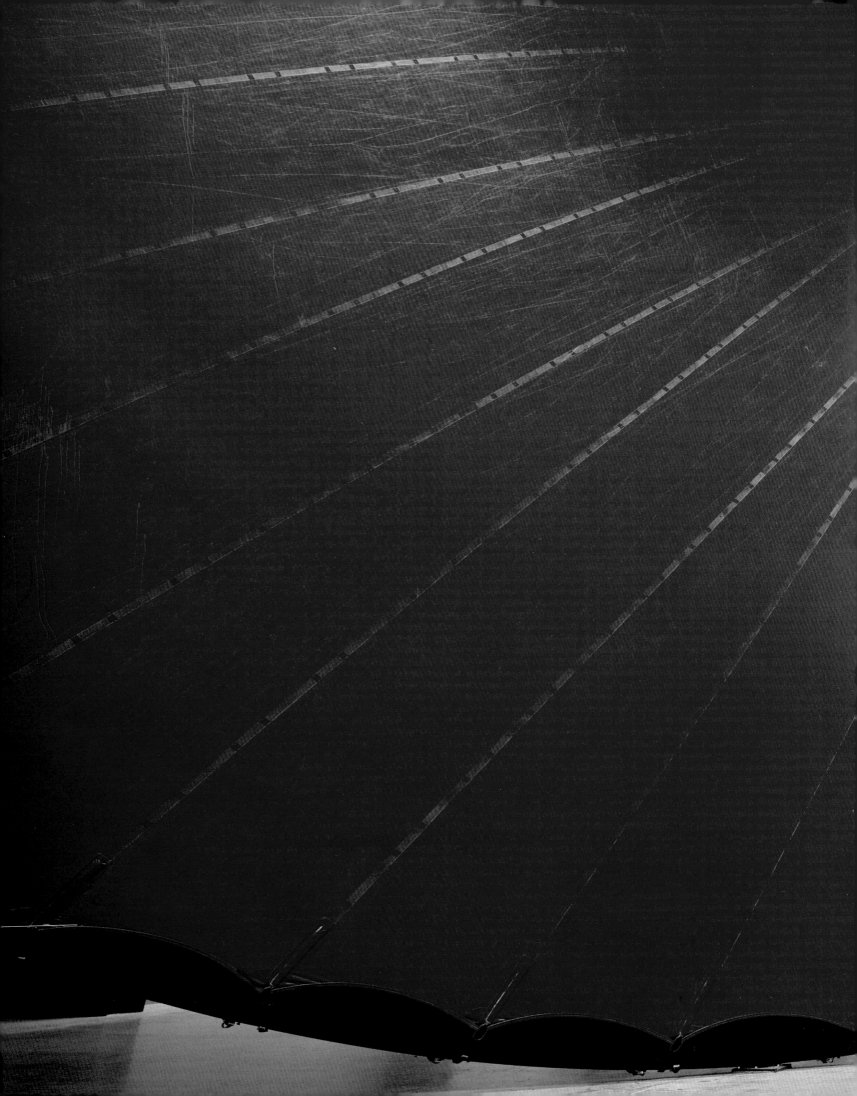

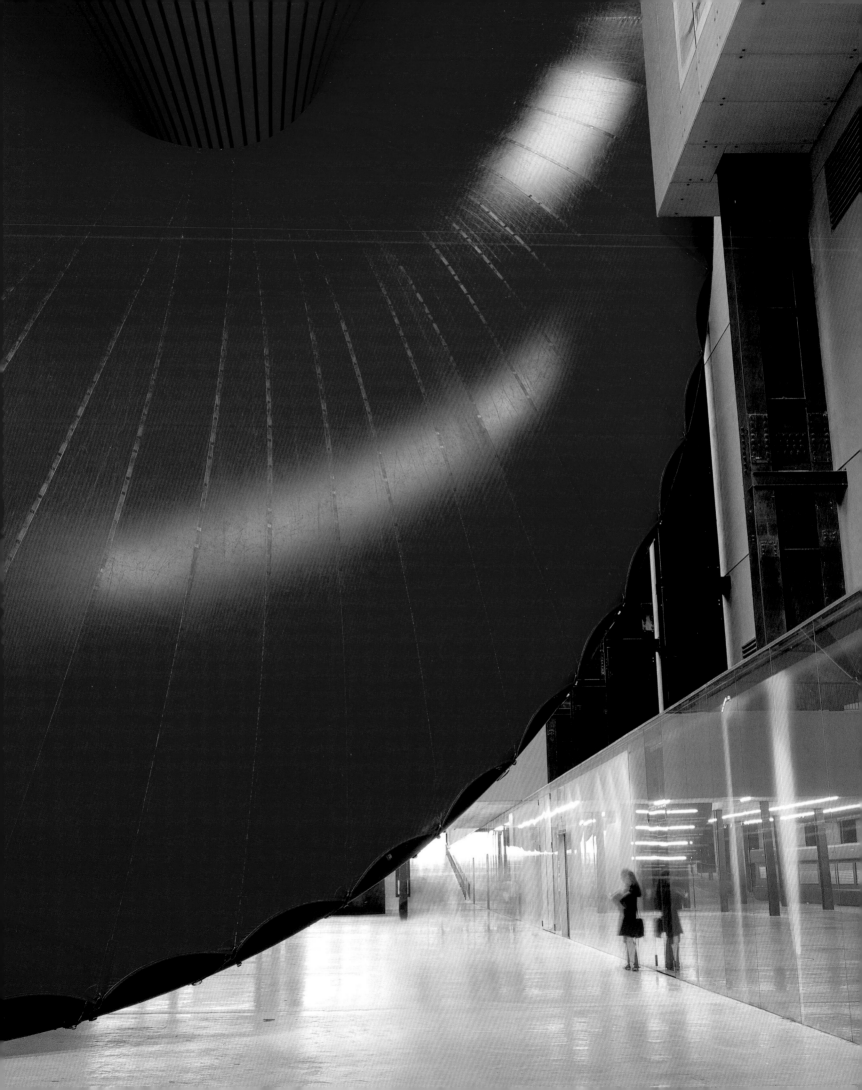

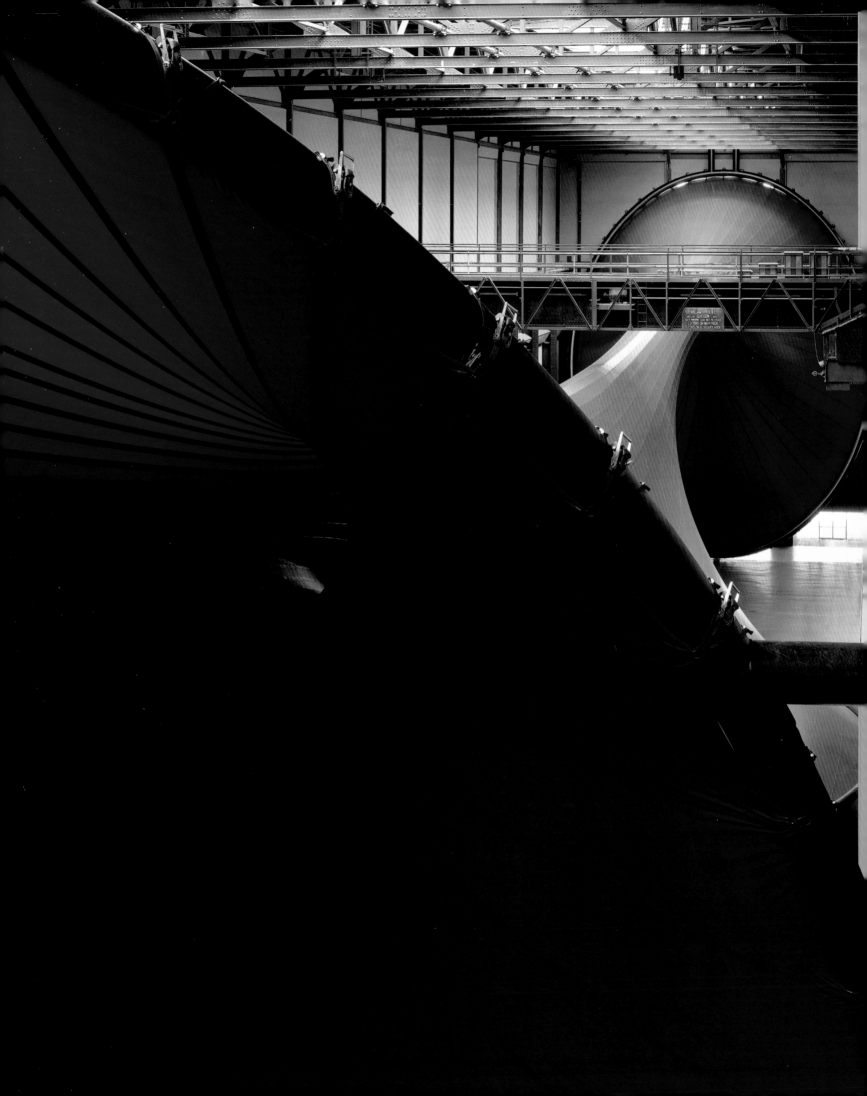

A Conversation

ANISH KAPOOR WITH DONNA DE SALVO

DDS The first question I'd like to ask you is how did the idea for this work begin?

AK I hardly ever think of a work without thinking of where it is, so in a way I don't always start with the work. But then there's a preoccupation in architecture that context determines what happens on site. That's bullshit. A good idea adapts itself to the site.

DDS Do you remember what your first impressions of the Turbine Hall were?

AK I've always thought of the Turbine Hall as a slightly glorified station – seemingly indecisive about whether it's an art space or not. The bridge always felt to me as if it was an intervention that was at best problematic.

DDS In a way, of the series, you're the first artist to engage the full length of the Turbine Hall.

AK Yes. Once you've divided the horizontal into three bits, which is effectively what happens by putting in the bridge, what you do is make the space more vertical. The problem is to deal with the vertical. You can't pretend the vertical isn't there. The solution right from the start was to deal with the full length, and by dealing with the full length one could somehow deal with its full height. And that seemed an equation that made sense, since every notion of sculpture that I've engendered in my work is anti-vertical. My sculpture seems to have a downward energy. Having understood this I found myself making two or three models within the first few days of being asked – sketches, maquettes – that set out the basis from which the work has developed. Surprisingly, or perhaps not surprisingly, it hasn't changed all that much.

DDS In certain ways it's remained incredibly consistent. But what has happened has been the addition of the centre portion of it.

AK As I began to understand the space a little bit more – not particularly by being in it but more in a sort of diagrammatic way, imagining the space as a box with a shelf in it – I felt that the problem was the shelf.

The bridge is essentially a viewing platform. Either one engages it or one ignores it. I felt that it actually added a wonderful possibility. It's as if it became the springboard for the rest of the space. The first notion was to take some kind of structure from the bridge up towards the ceiling – in fact, take nothing to the ground at all, make the bridge a space unto itself. If one can imagine a kind of tent from the bridge going up to the ceiling, which would divide the space in two, so that when you're down on the ramp or any of the lower parts of the Turbine Hall you would see the underside of this false ceiling.

I felt very excited by this idea. I believe that is an extremely elegant way of solving one of the sculptural problems of the space.

DDS By solving the problem of the architecture in that way, do you feel that you made a good destination?

AK Well, you enter the building and you're in the Tate. You then take a little journey up some steps or whatever and then in some way you're not in the Tate. It allows that order of removed experience that feels as if it's appropriate to this kind of thinking.

While this is an elegant solution to separate the space into sky and ground, it's too architectural. I don't want to make architecture. What then began to happen was that I started thinking about the way that that line, diagrammatically, might close itself; in fact I began to think in terms of a bean. The questions that it sets up are precisely the same.

DDS Dealing with the vertical through the horizontal again.

AK Yes. The bean sitting on the platform, which proposes a kind of beached whale in the space: an object so big – 120 metres long by 22 or 23 metres high, virtually touching the walls. And that was the moment at which

I felt able to have my first discussions with an engineer.

As the project developed I became very interested in a kind of spinal column hanging from one end of the building to the other, with a bifurcation; it just hung above the platform, completely suspended. It didn't touch the ground. A very sexual, emotive kind of form. I came very, very close to making the decision that that was the form I wanted to work with. I liked its objectness, I liked the way it seemed to connect with the building, and I liked its sculpture.

Two things made me think again about it. One was some very considerable problems that made the engineering of such an object much more present than I wanted it to be. And the other was that while one was experiencing the piece one was always in the Turbine Hall, in the Tate. There was nowhere from which it was possible, however momentarily, to not be in the Tate. The piece that I decided on eventually allows a moment of separation from where one is, causing one to readjust slightly ones mode of thinking, of actually being in the space. It felt deeper.

DDS The language of the bean seemed to be slightly more architectural than where things have come now. I don't know if you agree with that?

AK I agree only in one way: in the pure world of diagrams the bean by virtue of its scale (scale is something that one has to hold on to here) is all about form – as your eye moves round, what you see is form. And then going up and into the form . . . it ceases to be form, it becomes space. Something else happens and I'm interested in that conjunction. What happens in the moment when form ceases to be form and becomes space?

DDS This may seem a very basic, even maybe a ridiculous question – but what is form? Is it to do with interior and exterior?

AK I don't think it's as simple as interior and exterior. It's not adequate.

DDS These terms don't quite define it.

AK Yes. And I think that that has something to do with the fact that maybe we're trying to define something slightly different from those terms – something new.

DDS For instance the funnels, for want of a better word, have volume and yet they have negativity within them. It's a curious conjunction. They're both expanding and collapsing.

AK Over many years now I've made quite a few works that deal with this problem – the idea that the space within is bigger than the space as seemingly defined by the outside: the mirrored pieces, the works in the White Dark series, the void pieces.

DDS You mentioned that you're normally dealing with downward motion, but where you strongly dealt with upward motion was *At the Edge of the World*.

AK But even that I feel is actually dark and downwards and not really upwards. You may be looking up . . .

DDS But you think the mass is coming down. But this new piece actually incorporates both the vertical and the horizontal in a way you've never done before.

AK I've put up on the wall here three or four images. I've been looking a lot at Soutine, those flayed pictures of the meat, the skin that is stretched: I think that's something that's present in this piece for the Turbine Hall – the membrane is stretched. And then this Titian, which is the most incredible painting, *The Flaying of Marsyas*. There are obvious references in the Turbine Hall piece to skinning etc. It's just occurred to me that this work is a kind of cruciform – which is, of course, horizontal and vertical, or the resolution of the horizontal and the vertical. It occurs to me that in fact the flaying is a symbol of the transformation that occurs in the crucifixion.

DDS You have this capacity to deal with form in a very analytic, empirical way, and simultaneously search for what it suggests or what could be projected onto it . . .

AK I am really interested in things that we know, but somehow don't know we know.

DDS So the notion of the flaying and the crucifixion, these are things that come afterwards?

AK Not entirely. Form is never enough. It is the way it comes to have meaning that is the issue.

I just found this image, a totemic image, of a man wearing another man's skin – it is the overlayer. It's not just clothing, tailoring. I'm interested in the way that through conversations with engineers and others one can make the meaning of the piece. Meaning is gradually constructed, just as the object is constructed. I would like to feel that I encourage or allow a meaning to exist.

DDS You are acknowledging the nature of abstraction – that forms derive from somewhere. Where do these ideas about form come from?

AK In the Turbine Hall work the three rings set up a firm language that the intermediary form has to follow.

DDS There's an internal logic.

AK Well, there's an engineering logic, there's a fabric logic, there's a structural logic – all of which are more or less the same thing. When a line has a natural flow it will probably also be structurally correct. These things all come together. That logic leads to an object with a self-evident integrity. My interest is the way that they come together also with the thematic of the work.

I have always been interested in objects that have this sense about themselves – not that they were made but that they were always there. I feel deeply that art has a kind of religious function. Somehow it is not enough that an object is made, that it is fashioned: there is a need to go beyond the

fashioning. It's related to a very old aspect of Indian thinking that there are certain kinds of objects that are self manifest: they make themselves. The curious thing about these objects is that they *are* made – but their mythology is that they are not made. It's a very wonderful idea about the presence of form in the world.

DDS The interaction between you and Cecil has been interesting for me to observe. There is a meeting of minds, but there is also a different language – you approaching it through the language of an artist and sculptor and Cecil through the language of architecture and engineering. He is an artist too in his way, and that's probably why you have had a very good rapport. But you can take a structure and it can be architecture when pushed one way, art if pushed another way. What are these divisions and do they matter?

AK I think they matter enormously: intention is everything. One of the things that is fundamental to the kind of geometric forms we are talking about is that they are whole. They are not fractured forms. It is the acknowledgement of the wholeness of these forms that makes them architectonic. It's something to do with the form being fully contained within its own making. What I'm trying to talk about is ideal form, which is hidden in a certain kind of understanding of geometry. Cecil and I both understand this.

DDS And colour, which has the capacity to be so extraordinarily expressive. How did the decision about colour evolve?

AK I have a feeling that colour is emotive and not expressive.

Red has been central to my thinking for a long time, perhaps it's a cliché that one always starts with what one knows. For me there's a long process of testing my sense of how the colour functions against the form. I didn't want to make another red piece. Every intellectual impulse in me said make it

blue, make it black . . . Some of the thematic I'm trying to deal with in the piece is dark, I wanted to hold onto that idea, of the dark. I just couldn't get any other colour to work. I couldn't find the connections. I didn't set out to make a form. The form, I insist, made itself. I wanted to hold onto my ponderings on Soutine and on this late Titian. And this rather difficult area of some kind of transformational event – for ever I've been trying to turn the red of earth and body into sky. I'm trying to do the same thing again.

DDS It's interesting that this red, this deep red, this really dark . . .

AK It's a very different kind of red this time, but it is red, yes . . .

DDS It's a very different red versus, say, the Baltic piece.

AK Very different, that's orange red and this is very, very dark.

DDS At one point you said to me that the colour of the Baltic piece was a much more commercial red.

AK Yes.

DDS Whereas this red is almost the red of an Old Master painting.

AK It is. It's like some of the drapery.

DDS Another thing has been how the colour has evolved in relationship to the site.

AK We did an experiment together with different kinds of very dark red, a mixture of black and red that turned into a bizarre kind of purple in the light of the Turbine Hall, it was obvious, wasn't it, that there was no way that it could work. That isn't just to do with taste. The colour has to run into the content. It's obvious that either it runs into the content or it doesn't. I feel that that is a fairly objective position – as obvious to you as it was to me.

DDS It was.

AK There's this almost scientifically objective sense of a simple logic to the criteria that makes those decisions; it isn't an aesthetic choice. I can't say that loudly or strongly enough. The colour is not an aesthetic choice.

DDS And yet I'm not convinced that it's an objective choice either.

AK It may be a subjective choice, but it's not one that's based around taste. It has something to do with the content, therefore it is not to do with taste.

Maybe we should also talk about pink. There was a period of time when – such was my desire not to make another red piece – that I quite seriously thought about making a pink piece. Trying to see if it could work with a pink fabric. Interesting things happened. First of all, what it did was to make the object more like an object. I had one of the models painted pink. It made it more like a prosthetic limb.

DDS Yes, it separated it from the space.

AK Exactly. That lighter hue of red separated it from the space. Made it more physical. It just didn't feel as if it continued with the language of the work – to sit in this strange place between object and non-object.

DDS These are all highly industrial materials. You've always experimented with pure pigments, fibreglass surfaces, highly sprayed surfaces, materials that come from an industrial language.

AK The contemporary world throws up all these possibilities in terms of a colour spectrum that perhaps have never been available before. I've always felt a fascination with the modern, the industrial, the mechanical, the seemingly scientific – and then to use these materials in order to search for their opposite – the intimate and the sublime.

DDS How do you find intimacy in a space as massive as the Turbine Hall? Intimate is the

last word one would use to describe that space, yet the goal here will be that you will have a combination of feelings with this piece of almost terror, and yet the intimate.

AK I'm really concerned with the intimate. Art is good at pulling us into intimate relations. One problem as posed by the Turbine Hall is to find the intimate. I've often made drawings that indicate a very big scale, with some little person, some little figure standing there.

DDS Always in relationship to figure.

AK Always in relationship. Not since I was a student have I made any kind of figurative image and I don't feel the need to, I think the figure is implied. I work with non-figurative form to talk about the human subject. Human presence is always implied.

DDS Is it inescapable?

AK Yes, I think it is inescapable. There are certain kinds of forms that pull you in. One of the reasons why the funnel has been so important is that the movement from wide to narrow has a visceral effect.

DDS It's both an entrance and an exit. I've also been thinking a lot about this in relation to *Alice Through the Looking Glass* – that there's a sense of danger, awe.

AK I'm going to go slightly over the top now, but Yves Klein's photomontage of the leap into the void suggests a notion about falling, Apollinaire's falling, which is the body in a kind of free fall, the body given over to our dream of the angels. I have always felt and continue to believe that it is absolutely necessary to bring the viewer to that edge, to the edge of the cliff and to do what Apollinaire suggests, which is to push over the edge and then you fall.

I've made works that are holes in the floor, that are directly, if you like, the falling – but that falling doesn't always have to be downwards. The falling in some curious way can

also be towards a horizon or even upwards. Vertigo is at the centre of this thought – disorientation.

DDS None of these funnels are ones that you fall into –

AK Of course you don't.

DDS You fall up into them –

AK They might suck you in.

DDS It seems to me that unlike anything you've done before, except perhaps the Baltic, there's no way in which you can comprehend the whole thing.

AK I like the idea that the form is so big that you can't quite hold it in your head. It's important that the diagram of the piece escapes immediate comprehension. I am sure that eventually of course you get the diagram. But the time-lag is disorientating, and perhaps it is that disorientation that I am interested in.

DDS I have come back to looking at the resin pieces as linked to this one. You have the sense of a container, and this object within, but without definable edges.

AK I suppose the thing about those works is that while they are in a static state they seem to be saying that they are in motion. And I think that something similar is happening here.

DDS You are constantly defining form through all kinds of different materials and there is always a notion of an edge, even the very early powdered ones.

AK The Tate piece is attached to but disconnected from the architecture. It's an object, an object that does muffle or confuse the distinction between object and architecture, but none the less an object. And its objectness implies at some level that it is whole, it's not part of something. It has a kind of completeness. It is a whole/hole, in all senses of that word – which I like.

There was a moment when the work had symmetrical ends. One end was leaning into the west wall and the other end was square against the back wall. By turning the east end round by 45 degrees so that I could make it into a circle rather than another oval, the form became asymmetrical – or more asymmetrical (it was always asymmetrical, but not as obviously). That then shifted the physical centre of the work off the platform, off the bridge.

DDS It also further reinforces the notion of this thing as an object, although I don't want to say it's independent of the architecture, because it's generated to some extent in relationship to site. But you could argue that the centre of the building is the bridge, but the centre of this piece is not what comes over the bridge.

AK No. It may feel like the centre but physically of course it's not the centre. The other thing that interests me is that by making an oblique circle, one end of the connecting tissues between the forms is short and the other end is very long.

One of the problems in the Turbine Hall is to allow the transformation in the space to occur not by manipulating the architecture but through the intervention of the sculpture. Which I feel is an important distinction.

DDS In certain ways this has much more of the language of your other work. It's implicit in the Baltic as well, but this piece combines both flexibility and rigidity. What makes this work possible are the steel rings.

AK Absolutely.

I'm interested in the unknown here. There's one real unknown, rather like this man wearing the other man's skin – it's as if he's got a ring round his mouth, two little rings round the nostril holes, a ring round each of the eyes, and a ring round the ears. It's as if those holes define the intermediary volume.

DDS It's hard to know what is the edge.

What's especially unknown with this piece, I suspect, is what happens in the central ring.

AK Of course, it's the suspended ring that's a whole other territory. I don't know what tension the sheer weight of that ten tons of ring will engender in the rest of the form, or what will be the effect of walking underneath it – held up by the membrane, which is a millimetre thick.

DDS On one level there's a kind of delight in imagining what it could be and there's also a kind of fear.

AK Definitely.

DDS Let's talk about the scale. You'll gain something, but do you think you'll also lose something working at this scale?

AK At one level there's no accounting for the scale. And on another level there are metaphoric readings which are interesting, in terms of architecture, in terms of the ear, in terms of the body, in terms of all those referential things – scale models don't explain that really. My slight fear is the theatricality of scale, and whether scale places an emphasis on that aspect of a thing, which may be to its detriment. I've been struggling with how not to make a beached whale, because that is also a kind of mise-en-scene and I'm not interested in that.

DDS What might save it from being theatrical is that the size is absolutely integral to the objectness of this thing.

AK Yes. This is an object. I'm interested in the idea that a huge volume can be occupied by something which has effectively no weight.

DDS It isn't stone.

AK It's ephemeral and yet has presence. The monochrome ovoid leaning in on you as you walk in is like a throat pulling you into its interior; and the other end with the circle – a vast area of colour almost 30 metres in diameter – I think that has an emphatic kind of intimacy. But the hover is more complicated because it's not just colour – well it is

colour of course but it's very much about structure.

DDS It's actually much more structural.

AK The seams are being determined by the industrial process.

I could have made the decision to have a slightly different metre for the seams and have them every 2.7 metres apart rather than 1.8 metres. But I began to feel that the construction of the thing is so much part of what it is that I didn't feel that it was necessary.

DDS Just let it be.

AK Let it form its own language. One of the things that one has to take on board with scale is that the construction has a language of its own. When I'm making sculpture at any kind of body scale I'm very concerned that I don't want it to be constructed. I want it to be beyond making. Not made. Here, present, as if always present. As the scale goes up the constructedness of an object becomes less intrusive. It's as if one reads it as part of a given language.

DDS But you maintain the illusion in a certain way. With the works embedded in the floor or wall you don't see that structure. In the studio it's interesting to see what's on the other side but that's not what a viewer sees.

AK No. My work kind of denies all that doesn't it? What you get is not what you see.

DDS To some extent, although with this piece you don't see the internal until you get inside it; we do see the structure in a way that is different from *At the Edge of the World*. It seems to me that that work is a very fundamental piece for you, and that this new work might not have been possible without your first having created the other.

AK Definitely. First of all there's the horizon question. How does one make a full horizon? There are only a few ways that do it: one is

to make a hole in the floor, the other is to hang something above your head. The other thing that's occurring here is a certain blurring between the two-dimensionality, the surfaceness of the thing, and the very three-dimensionality of it. Perhaps this is the first work that is not only talking about a skin, but is actually made of a skin.

DDS Well again the rings – what I call the skeleton – define that. It's what changed it. There was a work in your last show, the styrofoam sketches with the tights. They felt like sketches – like thinking, drawing. And it's interesting how ultimately that element has been consistent. You couldn't do this in tights, so you found the material that does it in that kind of way.

AK Sure.

DDS I believe this piece is suggestive of your earlier work.

AK It is connected to the pigment works – I do see that.

DDS The idea of the coating of pigment. There pigment became skin.

AK The shiny pieces, the painted pieces, they all had skin. Skin is a consistent quantity in everything I've ever done. It's a notion that I've talked about in my work for twenty years now. Skin is the moment that separates a thing from its environment, it is also the surface on which or through which we read an object, it's the moment in which the two-dimensional world meets the three-dimensional world. Seemingly obvious statements, but I think that looked at in any detail they reveal a whole other process. There's a kind of implied unreality about skin which I think is wonderful.

DDS Again, it reinforces the idea of the ephemeral.

AK Yes, of the ritual, of the ephemeral, of the momentarily made.

June 2002

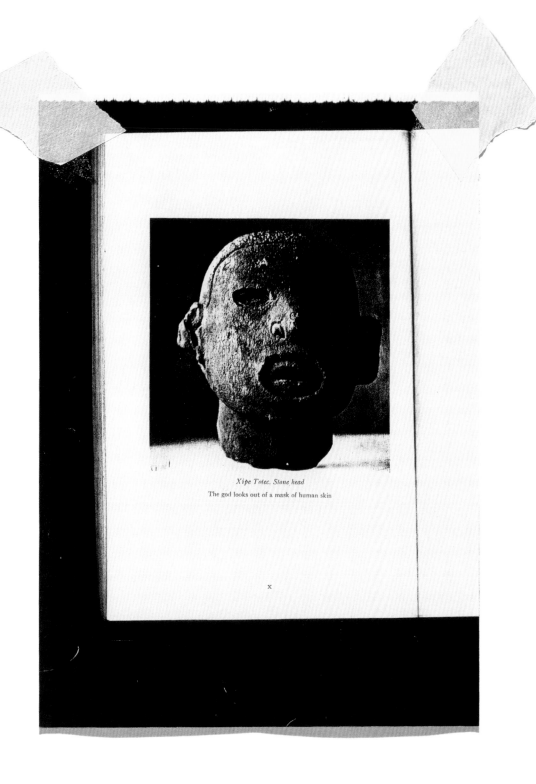

Xipe Totec. Stone head

The god looks out of a mask of human skin

x

Skinning the Imagination

CECIL BALMOND

STRUCTURE AND METAPHOR

As Kapoor's sculpture at Tate Modern takes shape and turns and climbs into space, narrowing only to expand again and widen, the form invokes the action of arch, wall, slab, even that of column and massive beam. The archetypes of structure – the imperative to span, leap the void, resist the elements and come down to earth in a collective surge at the foundation – are there. But no elemental line outlines an edge or frames the object, the undulation absorbs all. Surface bends into structure. Assemblies of lines and planes now merge in one confluence and spread over the surface of a warp. The discrete flows into the continuum. Structure runs in hidden currents; its vanishing provokes ambiguities, for which fold is now sinew or muscle? The guessing game is between structure and metaphor.

To build something, even to develop an argument, there is a particular logic of connection, structure realises meaning. But in buildings a structure usually buried beneath bricks and mortar behaves secretly, transmitting wind and gravity forces to the foundation, its actions not necessarily understood apart from that of somehow providing stability. Structural diagrams are also removed from reality; a line serving as the sign for a beam or column, an arrow indicating the action of a load, a dot is the centre of gravity of an object, and so on. Structure works like a ghost behind the scenes. This secret ambition to establish a transference from the real to the abstract resonates readily with the idea of a metaphor, to an action of shifting meanings. When we use a metaphor we assume the transfer, between words, of pattern – and a structure with its anatomy of line, zigzag brace, or contoured wave is already part of pattern. Either way the imagination is primed; structure and metaphor can act like twin poles of a magnet, each field of thought flowing into the other. And as structure gets buried in surface there is a tendency for that surface to maximise itself, to extend and grow in volume – one early idea was to do just that, expand the form, pumping up the shape to push against the sides of the Turbine Hall. Other models of a bean-like shape hung dangerously

over the mezzanine platform, the surface again wanting to swell and fill out the available cross section. In each case the work sought to be the principal conduit of the building. That a piece of cloth could fabricate this is remarkable, stitching surface and volume, the ideal and the pragmatic into one smooth unravelling; structure is forgotten, even sculpture in the conventional sense is lost. Unvoiced metaphors disturb the air.

SHAPING FORM

There is a difference between 'shape' and 'form' – we use the words loosely to mean the same thing, the image of what we see or look at, but even with the words 'see' and 'look' there are differences. Looking infers a desire to study and make critical comment, to see is to receive an image. The outward contours of something make up shape but, beyond that received image, an imperative of geometry and pattern mixed in with instinct and inspiration seems to hammer out 'form'. There is this intangible concept underlying form, more to do with creativity than visualisation. Trapped within its own outward layer, shape has no depth, but form has shape and depth; and structure, in its organisation and power of synthesis, allies itself to form.

Yet the search for a design begins with shapes as they are the descriptors. Only later do the attributes of form arise, as well as the judgements one makes as to whether the idea is robust and self consistent, or have opportunities been missed? Unfashionable words like 'Truth' and 'Beauty' dare enter the discussion too at this stage, serving as rough litmus paper to colour and check one's 'gut instinct'. In the end, mysteriously, something does feel right, there is that 'other' that suddenly says, go! The devil is that at first so much else also feels right. No certainties arise, only a sense of unresolved danger prevails running its nerve ends around the models.

COLLABORATION

To realise such a work (probably the biggest contemporary sculpture in the world and most likely the longest spanning fabric structure) the boundaries between artist

and constructor, sculptor and engineer fall, talents are pooled. Everyone swims in the same flux – hot inspirations and harsh realities. Only the endeavour that shares each other's sensibilities succeeds. Endless conversations take place (they should have been taped) and the 'we' in the text that follows is the collective noun for the intimate collaboration between Kapoor and Arup, led by his relentless eye.

But the trail to arrive at a solution is full of unrealised moments, the search being more of a clue to the nature of the enquiry than the answer itself. To annotate everything is impossible; what follows are snapshots of initial ideas and their development, a search that seemed at times to stretch the edges of the possible when something else would pull us in even deeper.

NATURAL SELECTION

Kapoor proposed three shapes initially: I call them the bean, two drums, and long spine.

The first shape, the bean, was to drape over the mezzanine in the middle of the Turbine Hall and cantilever past both ends into the void. Question: how large should it be, how should the diameter of the shape grow from neck outwards to the rounded ends? We thought a structure could be made to cantilever 45m, which would mean a total length of 120m for the object (the Turbine Hall is 150m) – and a space frame made up of modular steel elements could carry this shape. But where is the skin – should it be on the inner layer so that the steelwork is what the visitor sees first, or the other way round with the surface on the outside and all the supporting structure with its myriad connections on the inside? The bean could also be entered via the mezzanine platform and looked into, which would further emphasise the in-out idea of reversal. If there were an exoskeleton on the outside the steel could suggest some kind of halo surrounding the surface. If the structure was on the inside, converging around the concavity, we thought the steelwork would be finely dispersed and in perspective look like the growth of an interior fuzz.

Such metaphors, of fuzz and halo, are important, they serve as a beacon to draw out and refine a design. Otherwise the result may end up as nothing more than a utility of rods, nuts, and bolts.

But with the steel placed externally its mechanical aspect may not allow the subtle reading we had in mind of 'halo'. And what is 'skin' in this case? Something hard, smooth, and solid? Imagine the space frame modules being bolted together and a fine mesh placed over them, then a foam material sprayed on. The technique could provide a smooth surface on the interior and in contrast a rough unfinished texture to the outside as the spray bulged through the mesh openings. Alternatively, if the structure were on the inside, metal panels could be fixed as an exterior skin with gaps in between them to keep the panels planar, which would initiate facets to the curving geometry. Was the scale such that individual panels would 'jerk' the contour and not propel a smoothness? Another idea was to fabricate a single convex grid of structure, tied internally across by tension rods to make the cantilever stable, but then to place a fabric cloth over the skeleton and suck the air out revealing the structural pattern as a secret diamond ribbing. Kapoor called it cocoon. We liked the idea, it felt like the right direction to take if we were to develop the bean shape further.

The two drums, as I call it, were identical inverse parabolic shapes placed on each side of the mezzanine. Due to the opposition of forms – two parts, left and right, sucking, pulling, different polarities yet one composition – they produced an interesting dynamic. Again there was the discussion about hard skin and exoskeleton or interior fuzz? But was not the shape ideal for a single skin fabric structure, and if it was fabric would it be similar to Kapoor's past work at the Baltic Mills? Though the forms engaged the space within the Tate in a provocative way the idea had a familiarity to it – and we put this one aside for a while.

SPINAL TAP

What intrigued us was the long drape. I was drawn to its hybrid nature of spanning as a cantenary on the top surface but breaking into two parts at the lower half and arching. As in all the ideas we studied there was an exterior aspect of looking at the object and then another narrative engaging with the form by visiting the interior. This shape spanned the length of the Turbine Hall. Elegant in its long sweep but brutal as well in its no-holds-barred occupancy of space, the long spine pressed against walls and clamped down on the mezzanine engulfing the whole middle section. The form acted like an armature of sorts, like a spinal tap on the energies of the Tate. Made of fabric, it would be a smooth spiralling against the stark columns, plated beams, and metallic overhead cranes of the Turbine Hall. We were ready to press the button. (The two drums were now a distant memory. The bean, though fascinating, was put back on the shelf for another time.) Three months had brought us to this point, and we had committed to the form that would risk the most.

Then another idea challenged: to lift the form off the platform and give it dangerous life, hanging the whole construction in space, bifurcating the shape as it ran towards the centre. If the form billowed out over the mezzanine it would hang low over the visitor's head, threatening, drawing a new horizon around the edges. The longitudinal cut or cleavage into the shape could run for two-thirds of the length, deepening towards the centre. It looked shocking and sexual. It was also exciting and lyrical. If, as Kapoor proposed, the fabric was mirrored, the surface would recede and progress in other subtle geometries, reflecting dimensions beyond the curvatures we had dreamed of. The reality could only be guessed at. We thought – wow!

BODY PARTS

A structural notion had triggered the idea of bifurcation within a pure hang, and not engaging the mezzanine, but now the structure itself was the limitation. How could a skin swell and be cleft at the same time? Would eight

tons of polyurethane pellets thrown into the twin bellies of the form fatten up the volume as if the pellets were acting like internal liquid? A tension cable tied to the extremities of a vertical diameter of the tube could pull the shape in to create the bifurcation (in the same way that tension fibres on the walls of a biological cell pull at the skin of the membrane to fold it inwards and begin cell division) but doubts multiplied as to the accuracy of our predictions. Would the contour of the cleft be spiked or rounded and smooth? Would the interior ballast of pellets be lopsided, to produce a shape that would bulge in uncontrolled ways? And a mirrored surface we felt would be unforgiving of any blemish – the sample hung and folded in Kapoor's studio proved this. So we abandoned this enticement but kept faith with the idea and went on to study other ways of providing internal pressure to swell and shape the form; pumps, discrete forces placed internally and so on. But was this right, to look at a form and not know it had hidden interior ballast? Should not the work be understood more explicitly – what if the form were cut open above the mezzanine as Kapoor proposed and the ballast moved to the outside as a heavy ring, pulling down at the edges? There is no sealed chamber now being pumped up, instead a weight borders entry into the form. Like a giant ear the construction is open to our whispers. There are no unknowns – everything shapes itself between the end anchors and centre annulus depending on the bias, cut, and warp of the chosen fabric. The computer realisations looked fantastic.

Finding the right shape though is painstaking. With fabric a particular geometry cannot be easily predetermined. A special computer program begins by assuming a profile, then loading it and allowing it to move, adding pre-stress to stiffen the form. While the structure searches for equilibrium to balance deflection against applied force, the position alters. And the iterations go on. What is sought is convergence. Once that is achieved, small alterations to the physical model cause significant computer time in checking out the stability of the cycle again – load – deflection – pre-stress – load – deflection

... etc. Once the geometry is fixed, the shape is then fabricated as a series of longitudinal strips, cut in a specific way, so that when stretched the form would have no wrinkles, no ridges, only a smoothness. That is the theory. In practice fabric structure needs tolerance or 'give' in its fastenings so that if unwanted wrinkles do appear, after the cloth is stretched, there is room for adjustment.

But these factors alone – of material and form-finding, though complex and sophisticated – do not make the work. Colour adds life. Kapoor chose a deep red that had darker coagulations in it, viscous, blood-like. The problem is that colour lacquer has to be applied as a film in a particular way with structural PVC fabric, without that layer 'lifting' off and laminating. Special trials are needed.

The trials could not yield the varying dark tones we wanted; but a sample of another deep red hung in the studio produced different colour shades, as the cloth changed its curvature. The skin seemed to grow flesh beneath the red lacquer. I could see the technical abstractions we had struggled with – of warp, cutting patterns, and tension trajectories – materialise and thicken into muscle and bone and sinew. Strange that colour, that slightest vibration to the eye, should apply the strongest force.

SKINNING THE IMAGINATION

As a 28m-diameter hole sucks you in, the circle pulls away and climbs up rapidly, narrowing, the seams of the fabric move onto a small passageway high on the cusp of a sweeping curve. That red orifice, like a throat, swallows the eye and squeezes it past into a vanishing. As the visitor escapes the suction and runs into the Turbine Hall the story unfolds of an arch that leaps and dips down to hover threateningly over a far land of the mezzanine. Again, a gaping hole is the only horizon. This time is it mouth or giant ear? Another arch leaps from the platform to come down on the other side towards earth, foreshortened, flaring into a circle as a mighty steel ring pulls it down and tensions the fabric. Through the open passageways, flying arcs and saturated colours, another force stretches our preconceptions and startles us with intense pictures. Something tough and resolute yet deeply disturbing pulls at our minds. Somewhere between memory and what we see, a hidden structure acts on our emotions with phantoms that shape visceral feelings. Nothing can be talked about, only felt. The imagination is exposed – raw, vibrant. Here at Tate Modern, with Anish Kapoor's work, preconceptions are stretched and warped into altogether another reality.

Acknowledgements

Any job in engineering design is a team effort, and the fantastic efforts of Tristan Simmonds in the process of form-finding, along with Chris Carroll's lead and organisation, must be recognised. I am indebted to Charles Walker and Brian Forster too for their expert advice on fabric and tensioned structures.

Towards Marsyas

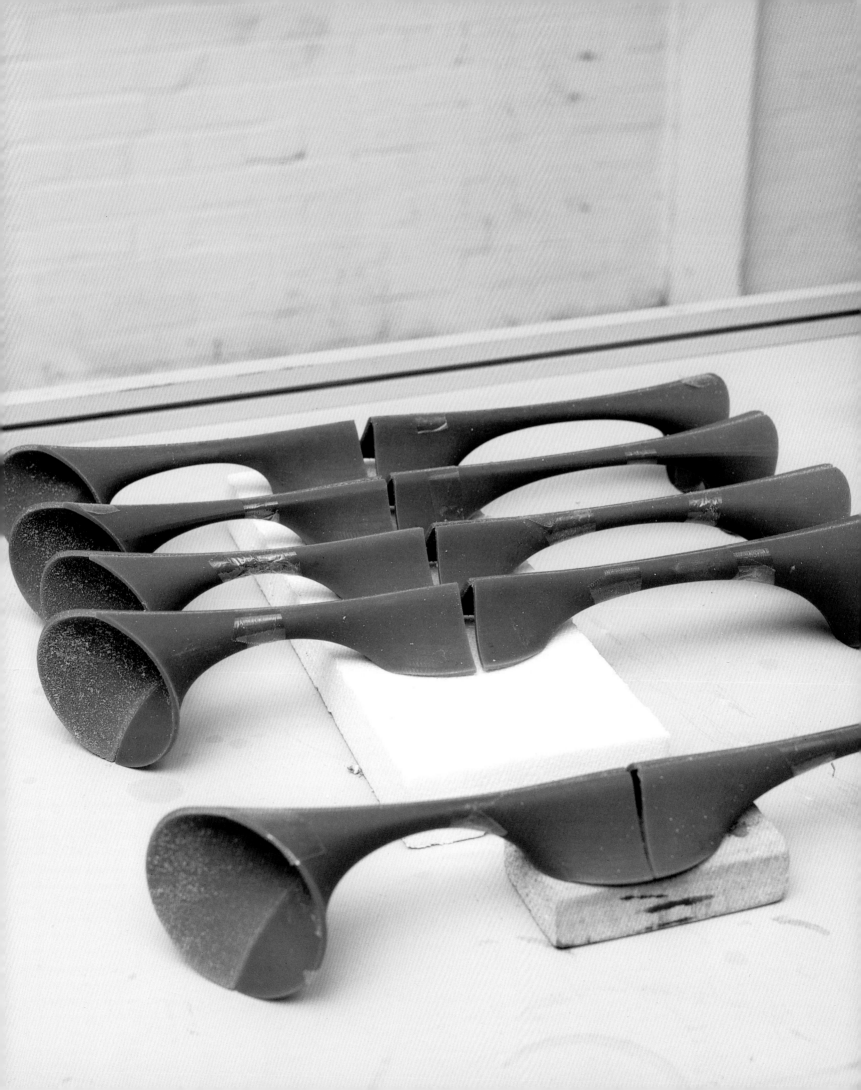

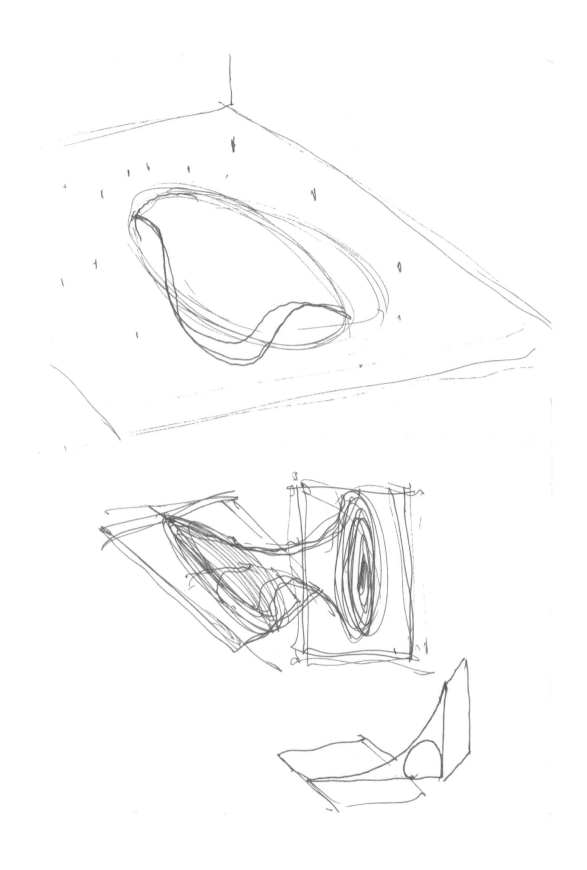

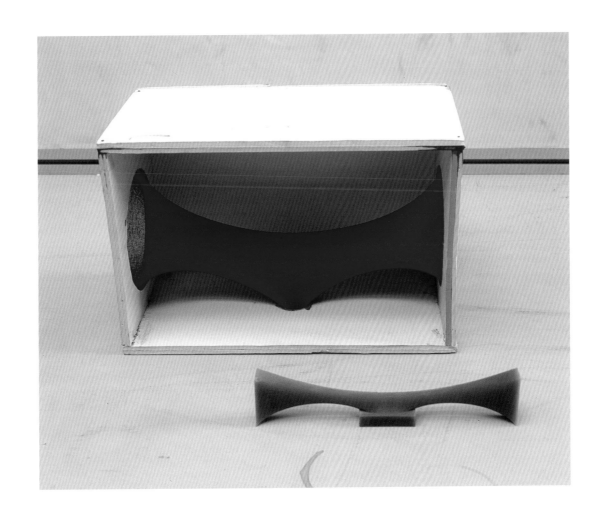

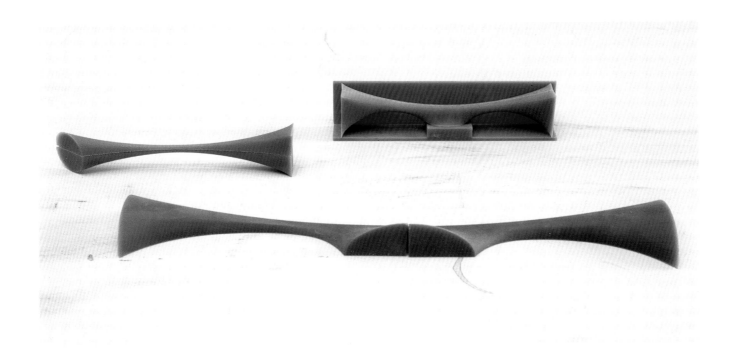

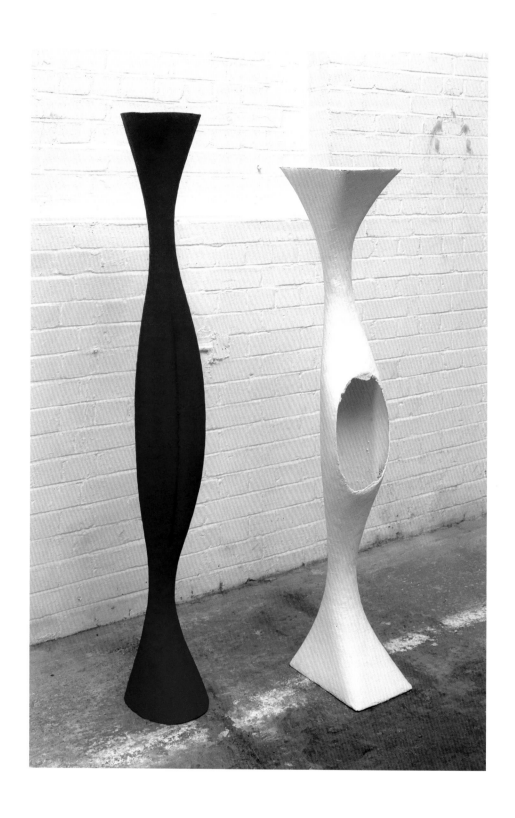

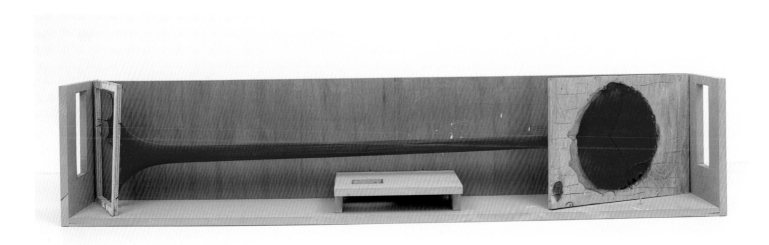

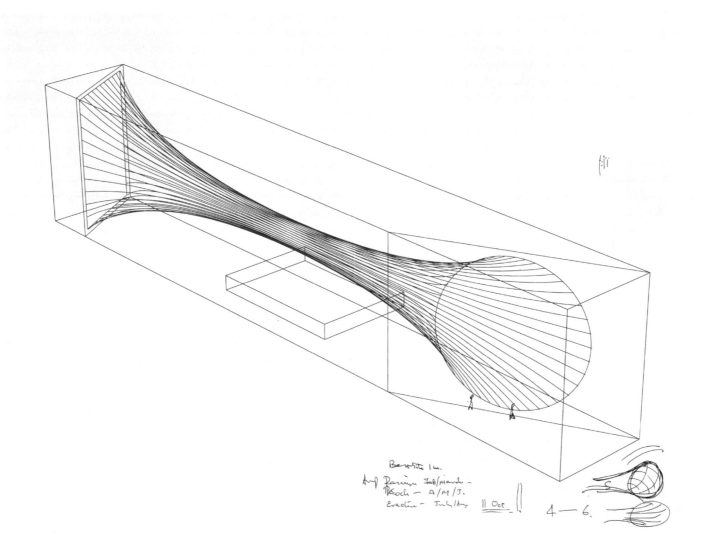

Cast Steel

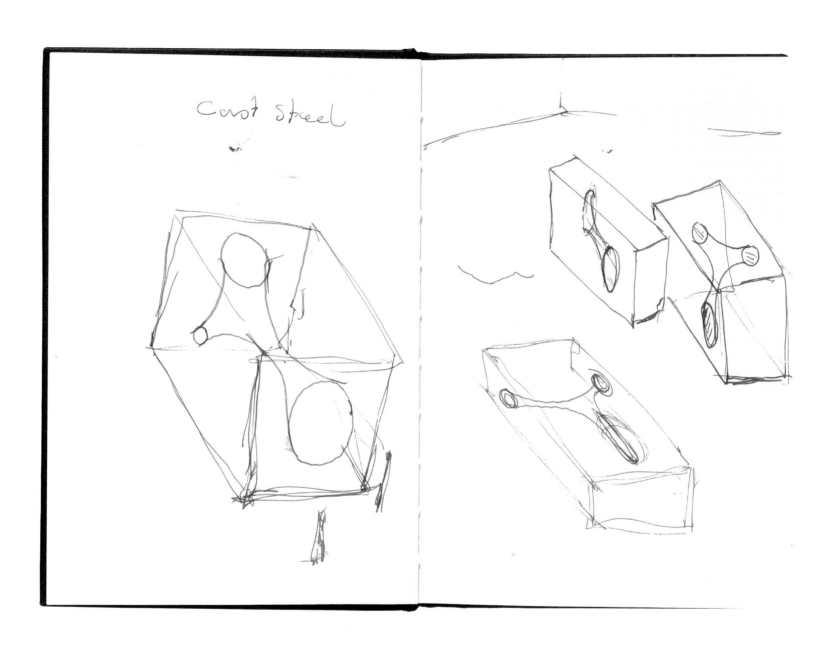

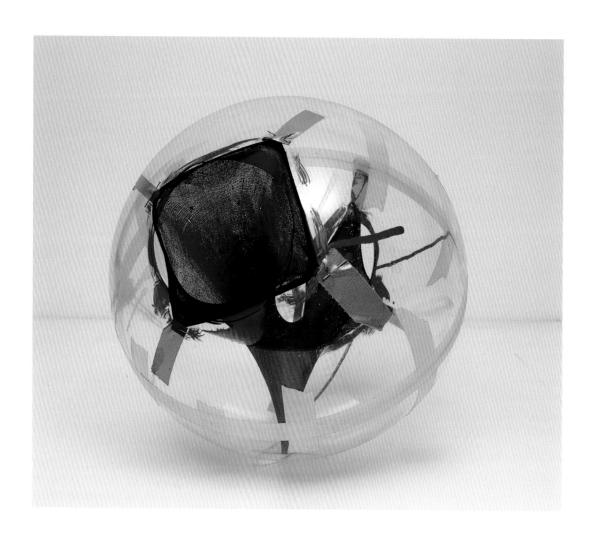

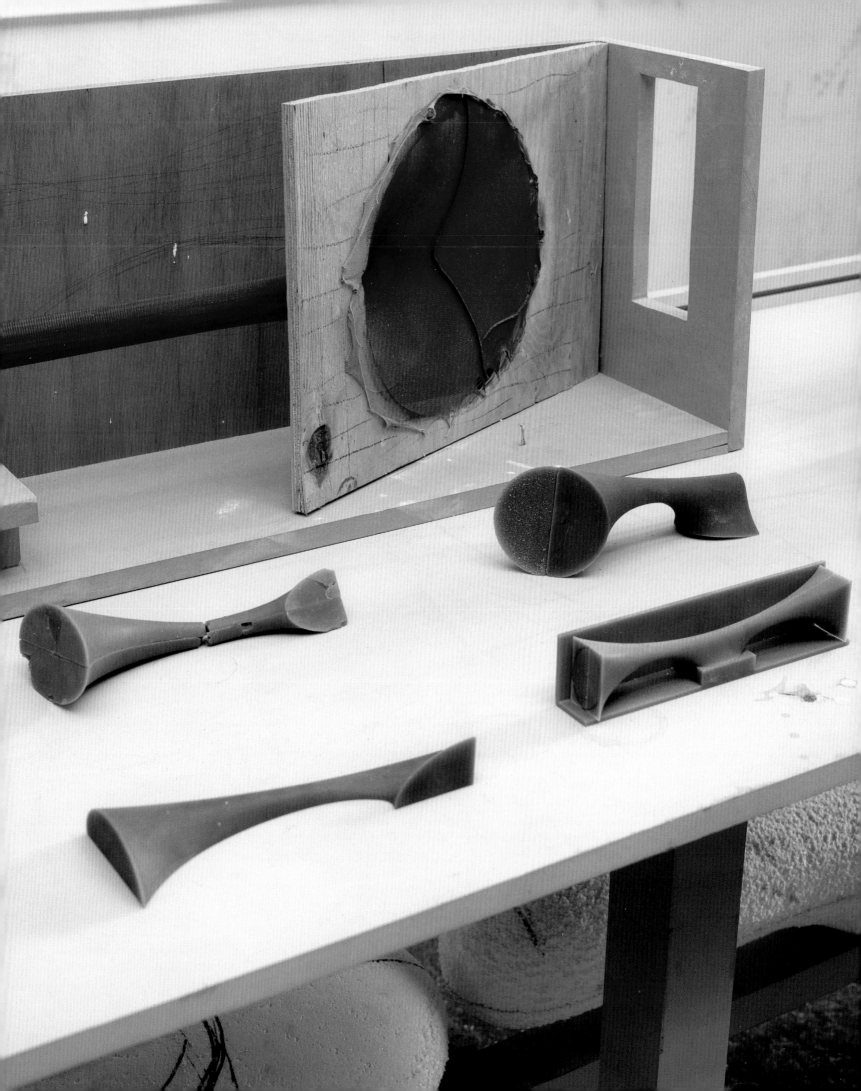

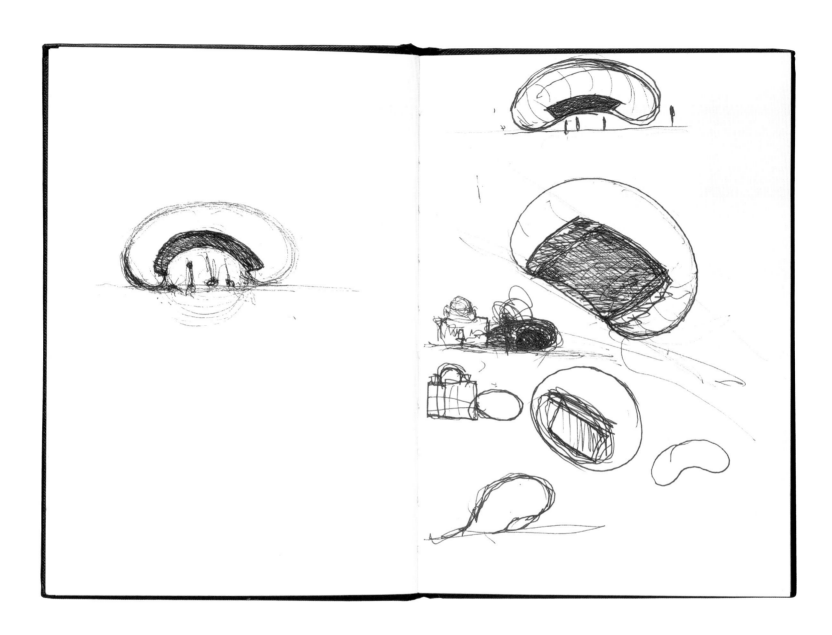

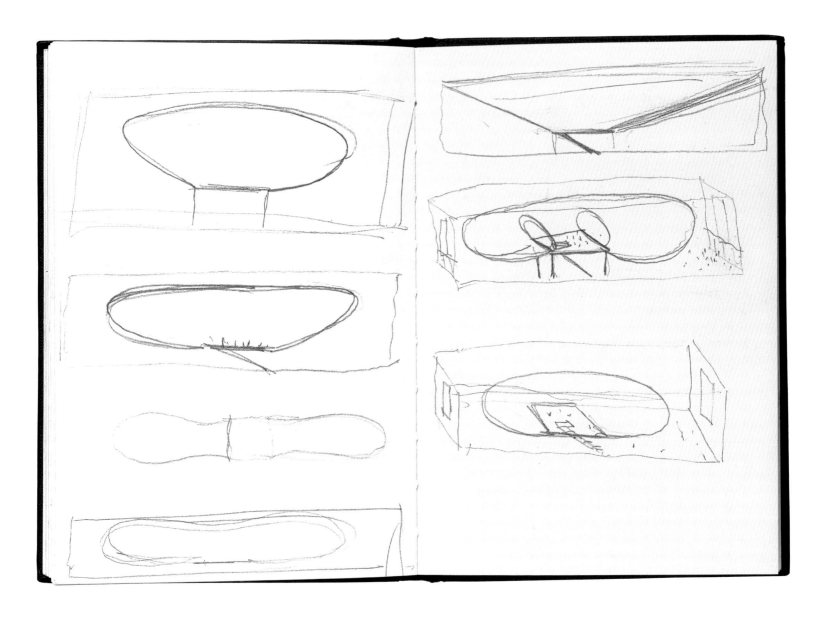

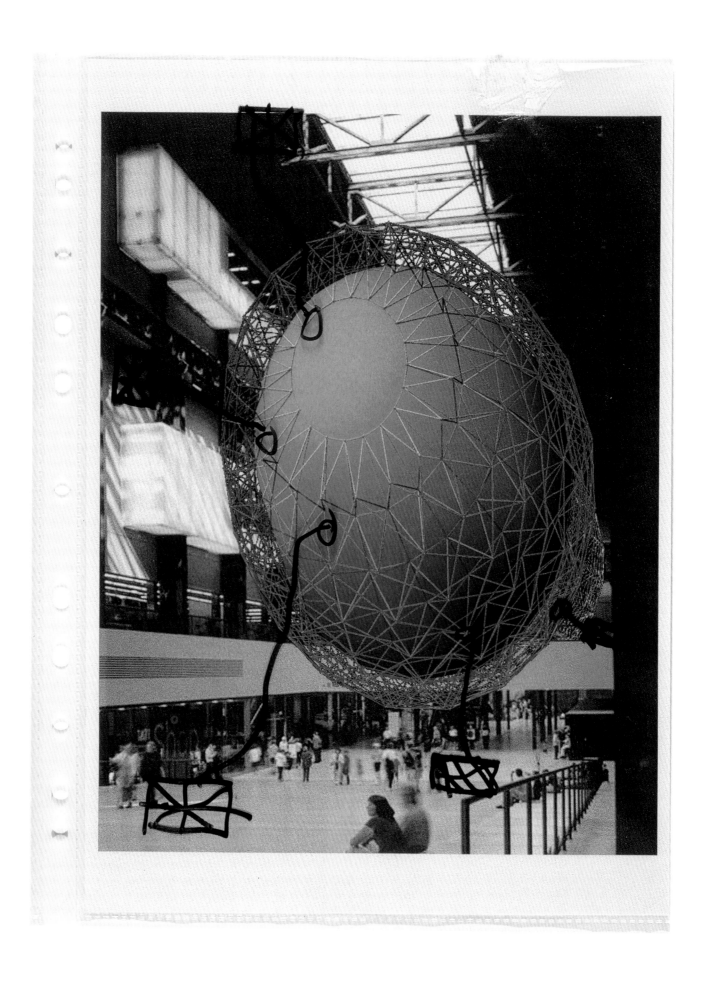

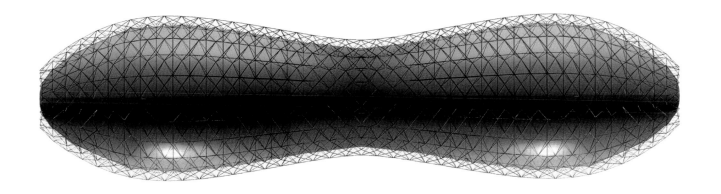

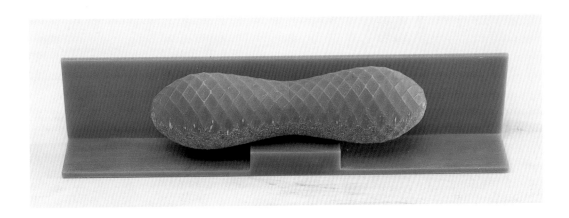

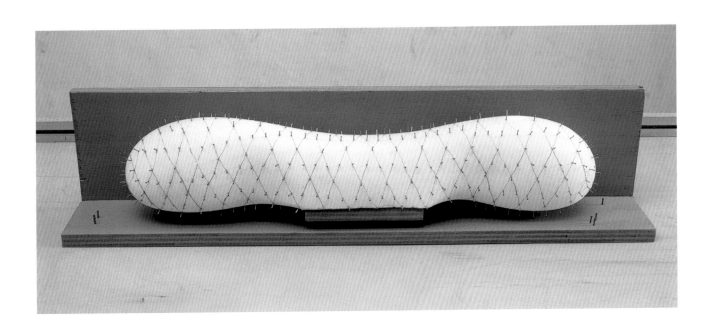

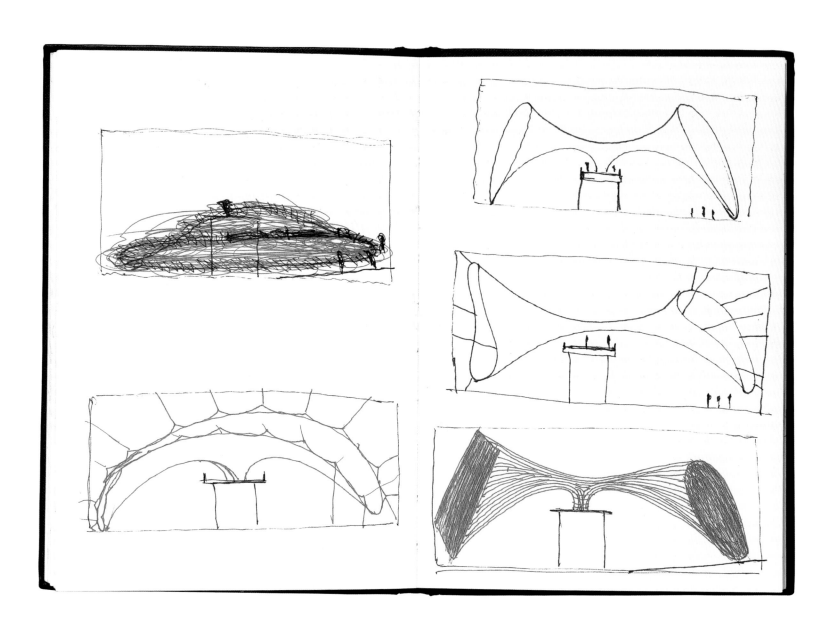

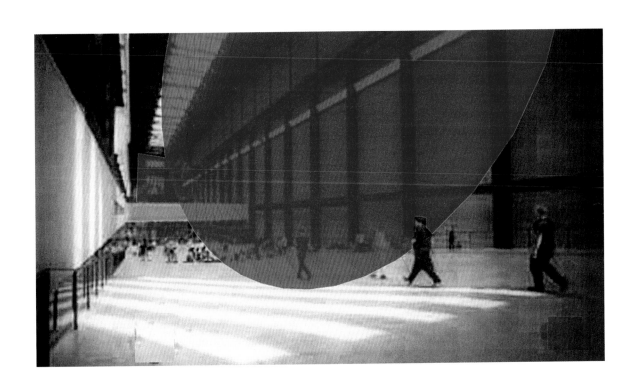

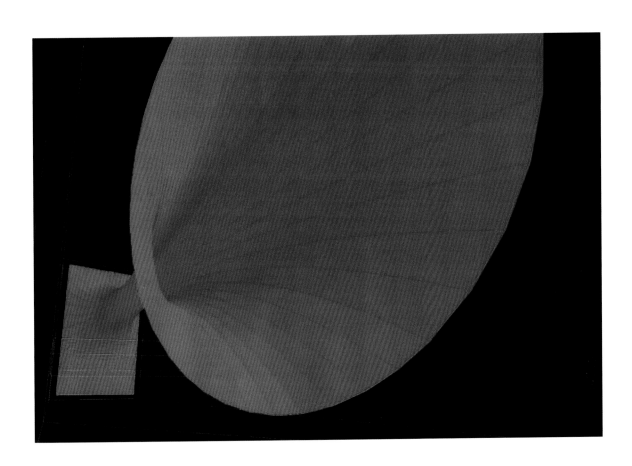

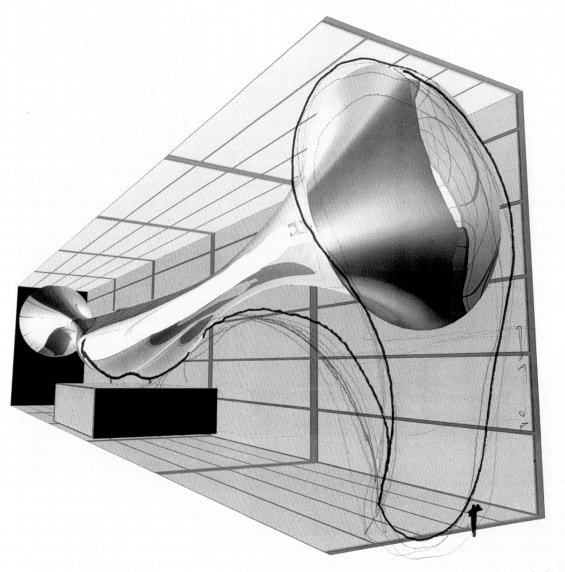

Arup Complex Geometry 2002

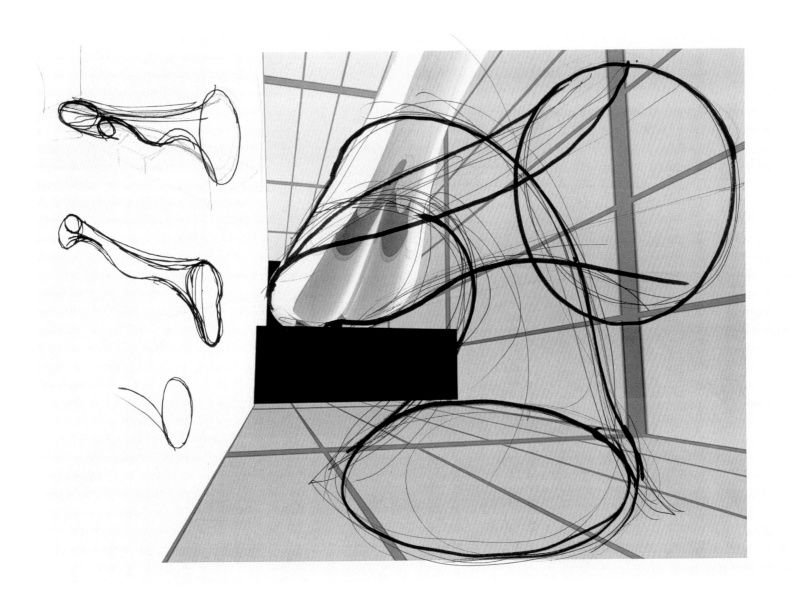

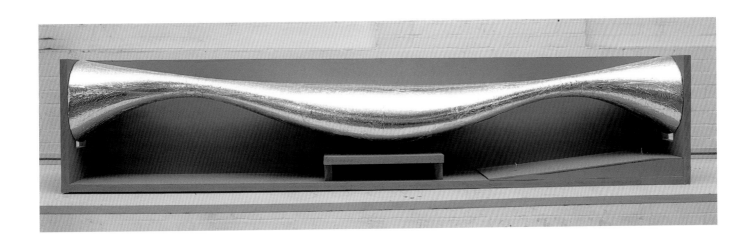

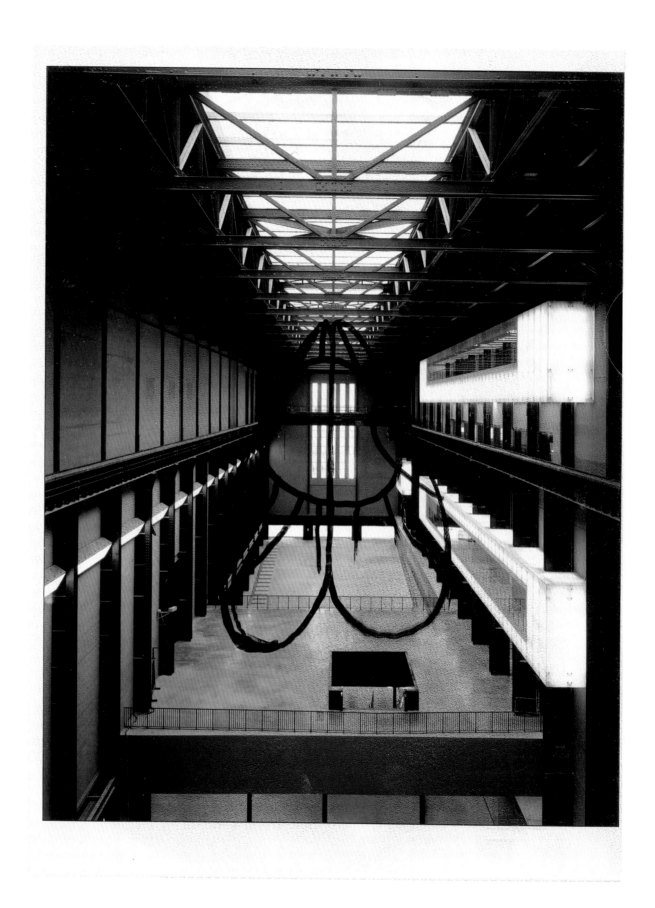

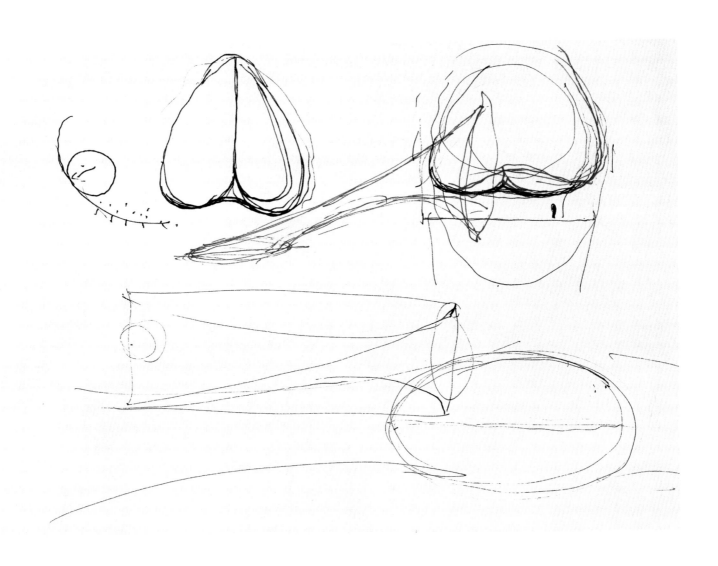

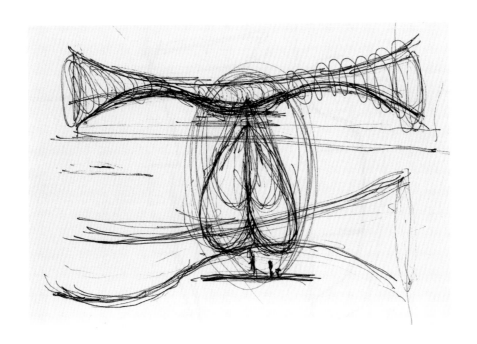

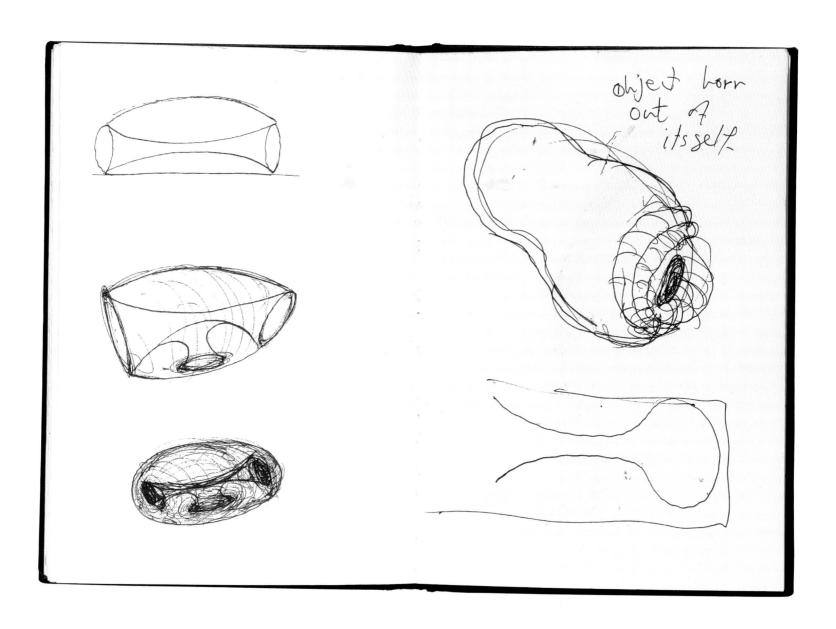

object born
out of
itself.

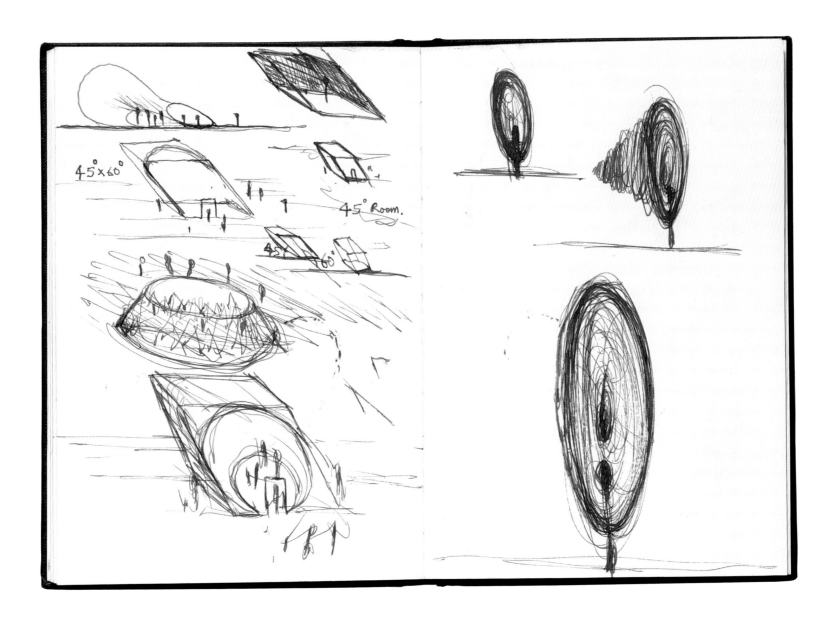

45° x 60°

45° Room.

45°

60°

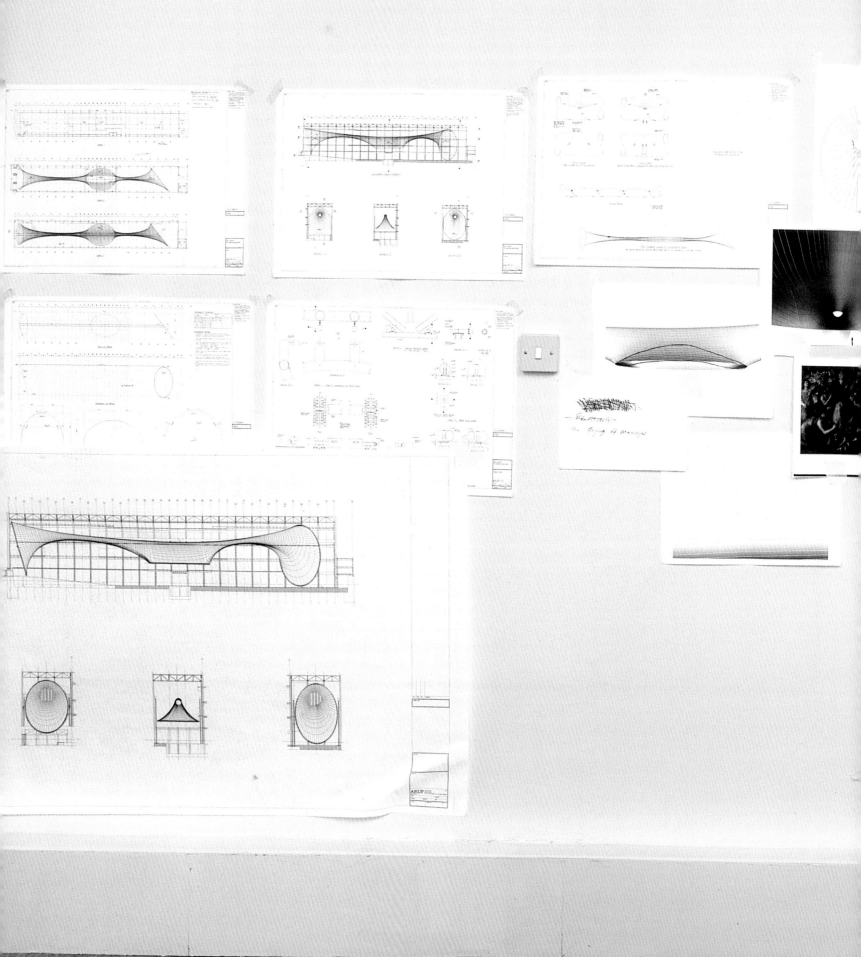

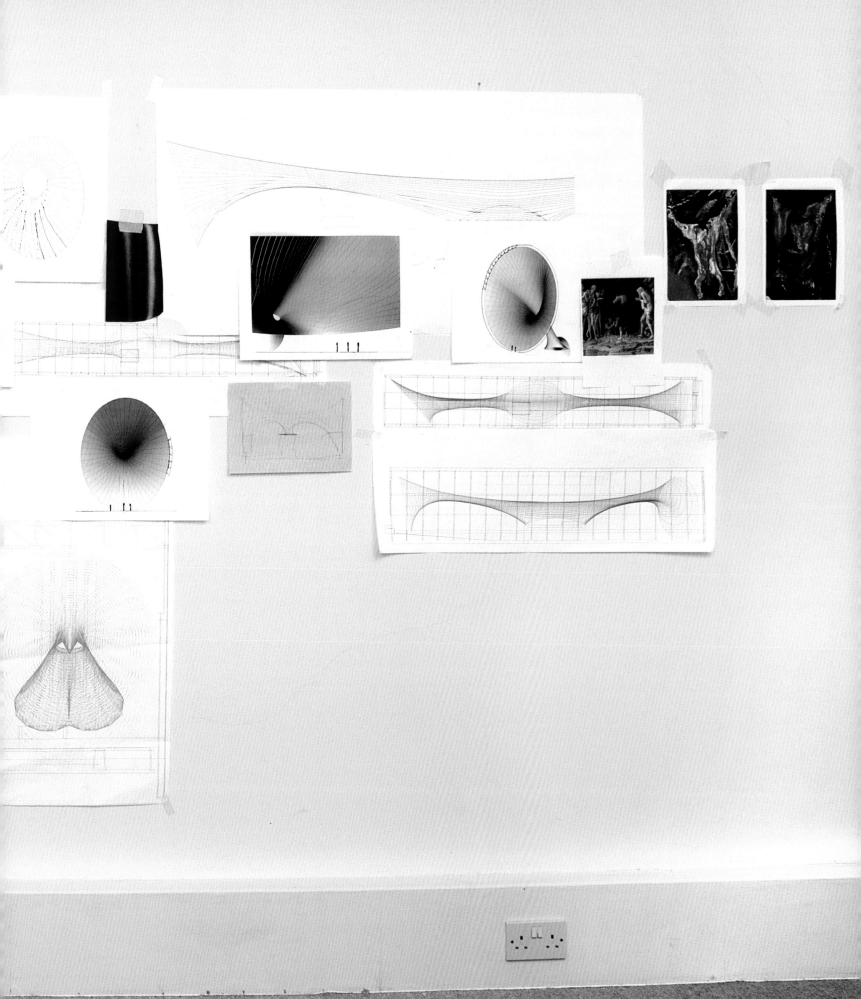

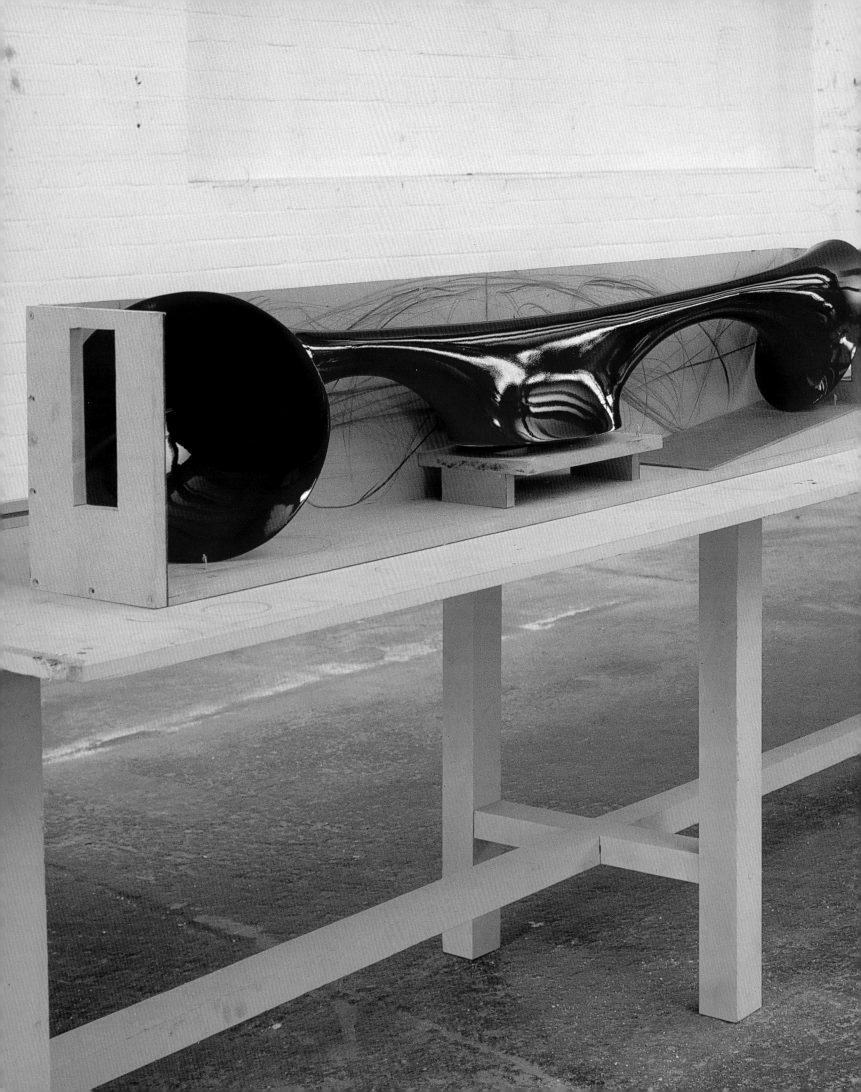

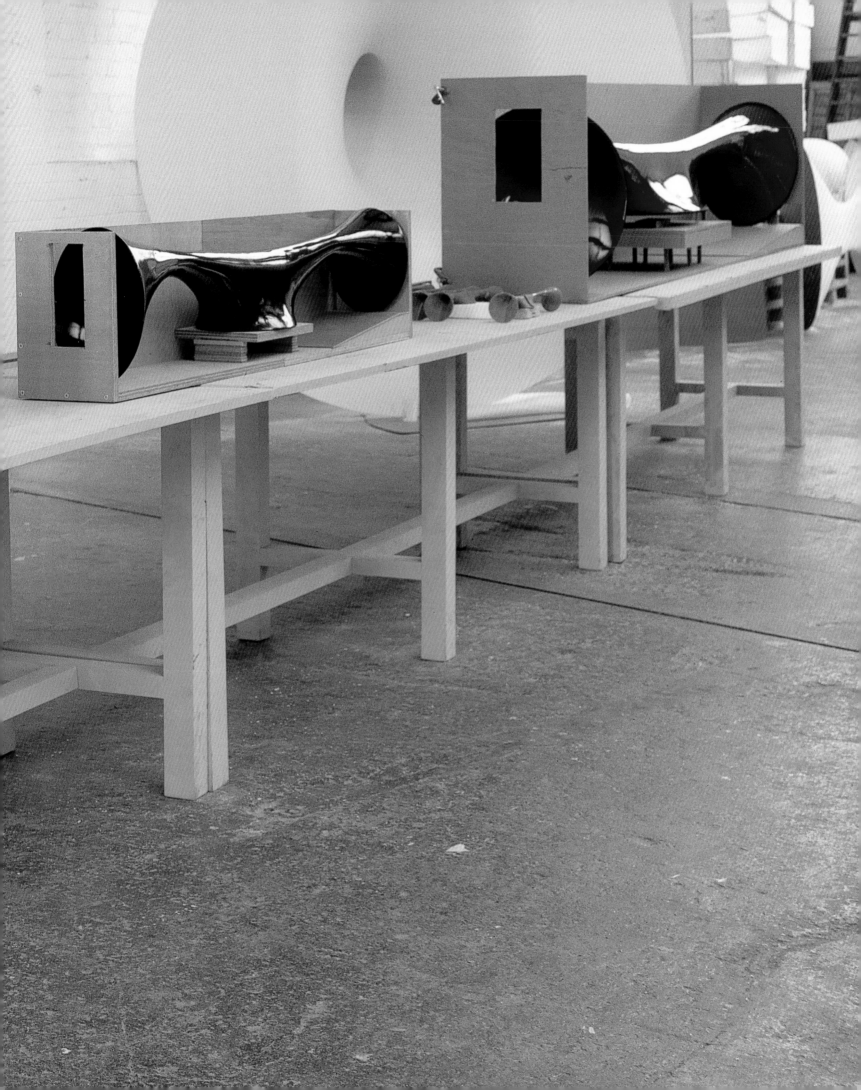

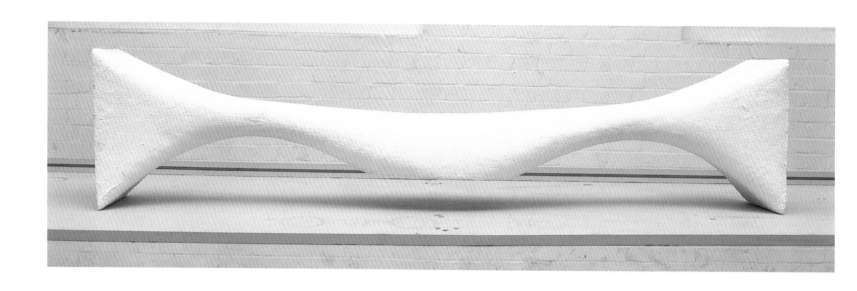

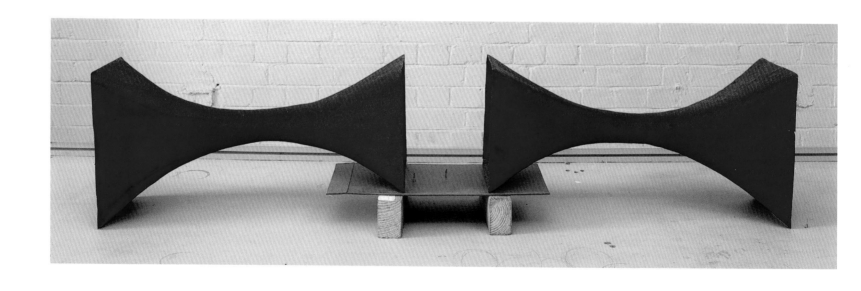

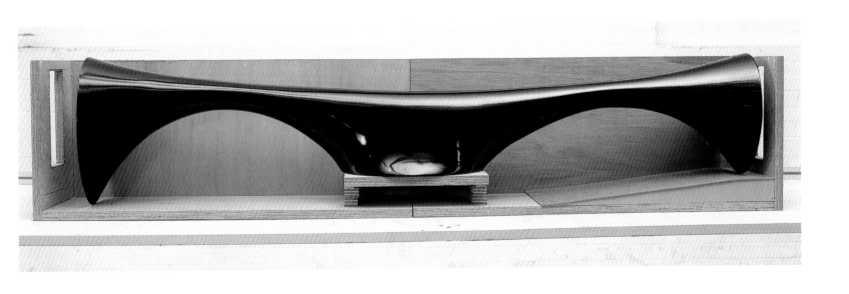

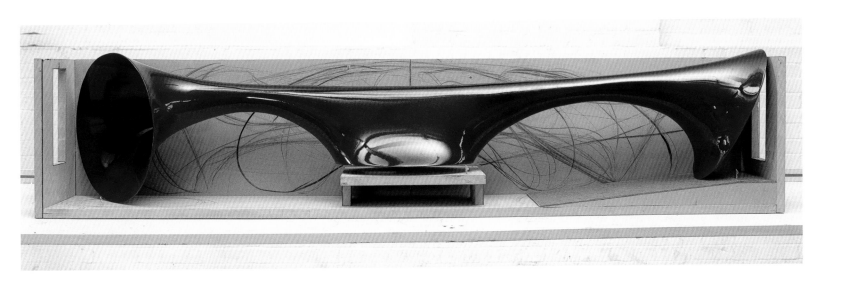

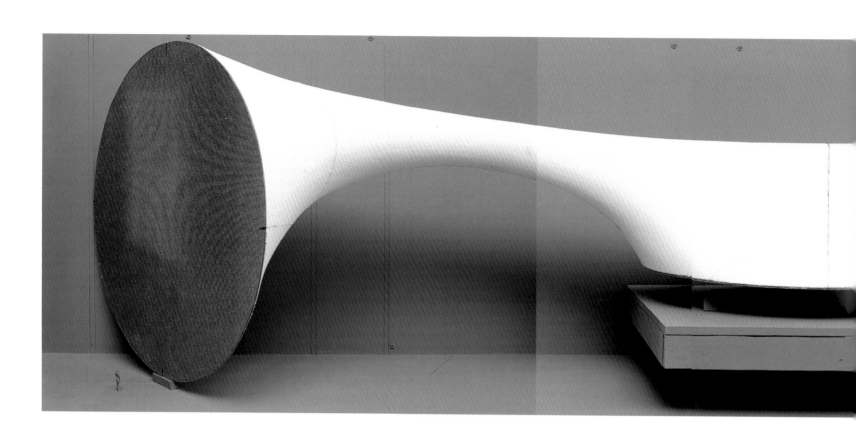

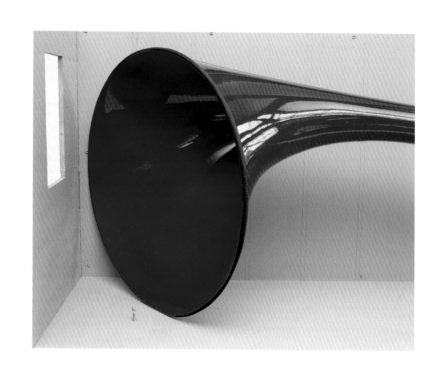

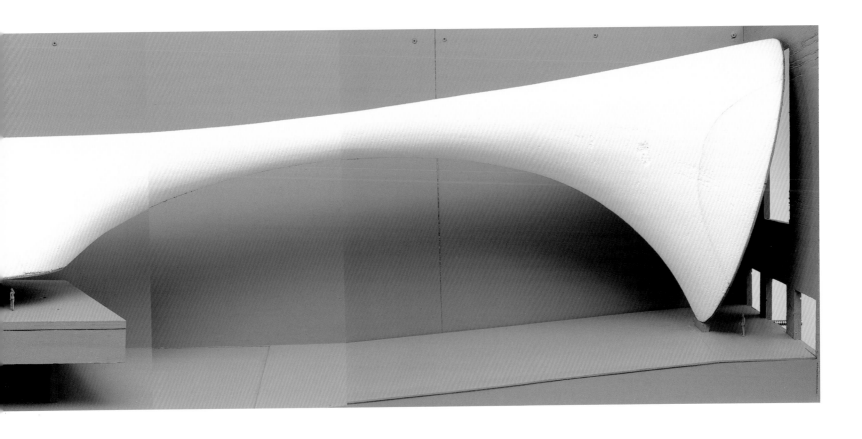

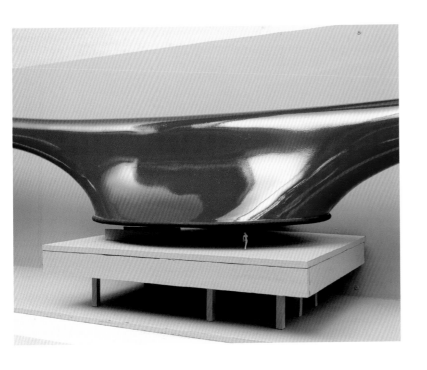

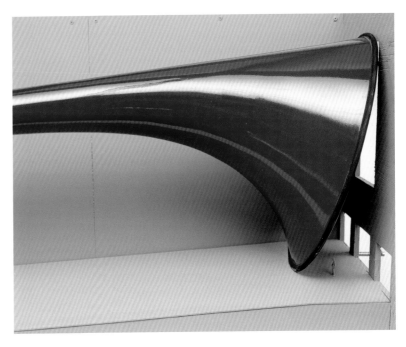

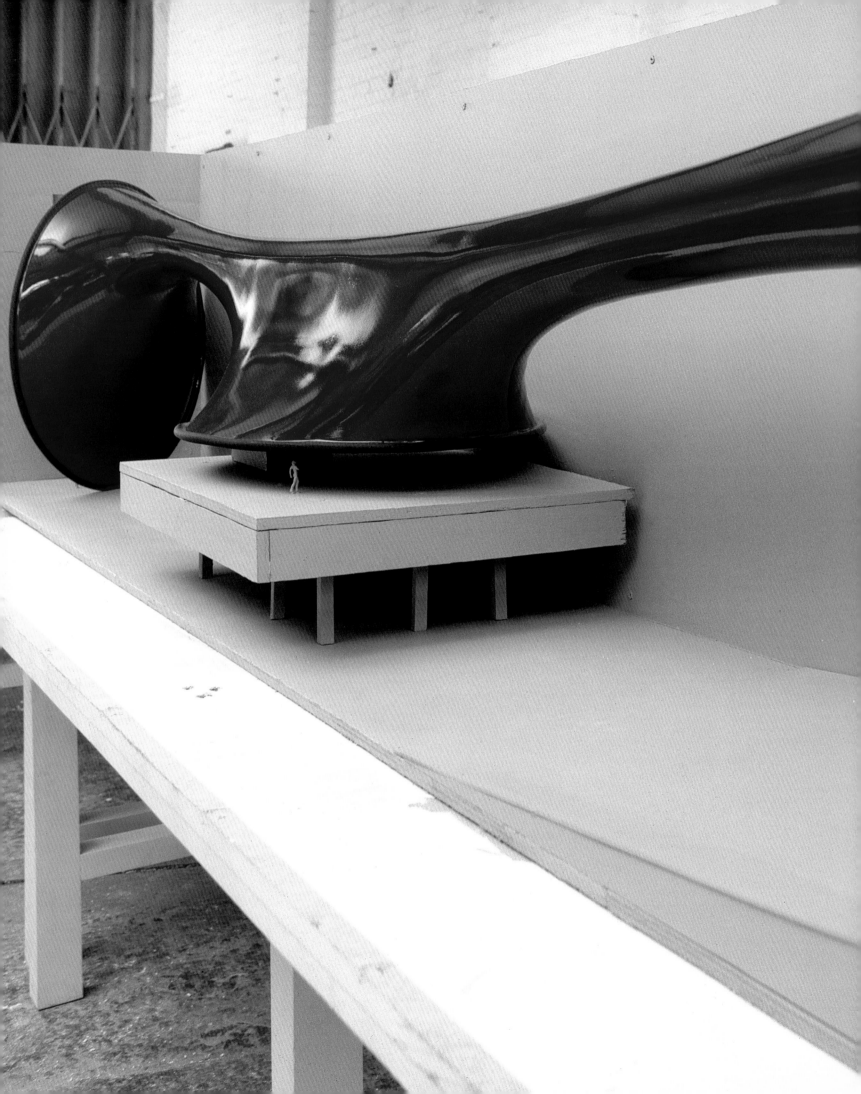

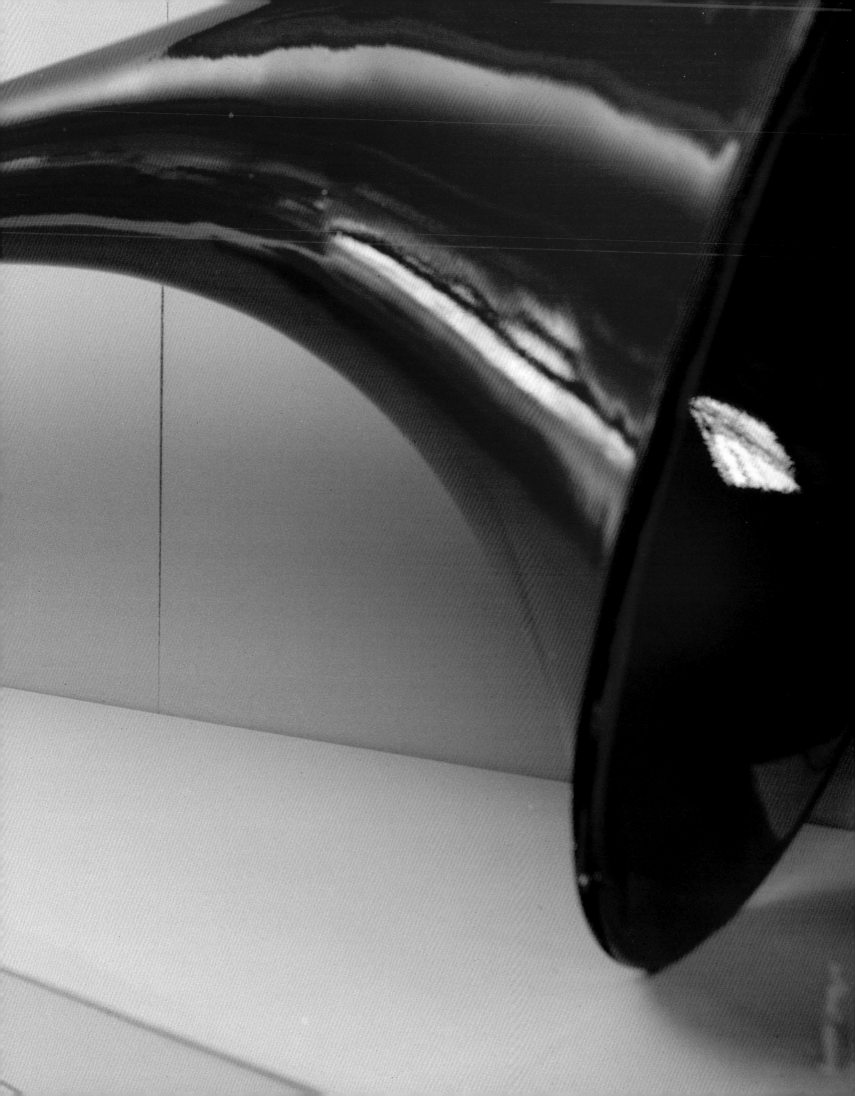

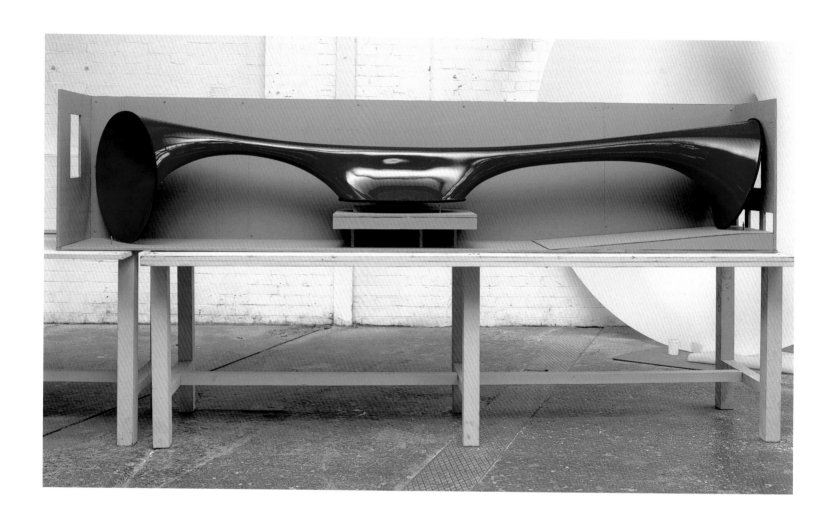

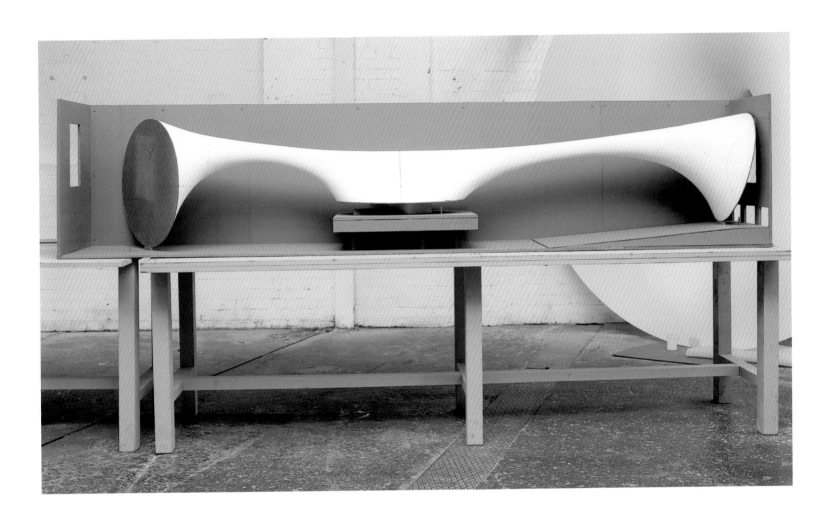

Chronology

COMPILED BY SOPHIE CLARK

1954 Born, Bombay

1973–77 Studied, Hornsey College of Art, London

1977–78 Studied, Chelsea School of Art, London

1979 Taught, Wolverhampton Polytechnic

1982 Artist in Residence, Walker Art Gallery, Liverpool

1990 Awarded 'Premio Duemila' at the Venice Biennale

1991 Awarded Turner Prize

1997 Awarded an Honorary Doctorate at
 the London Institute and Leeds University

1999 Awarded an Honorary Doctorate at
 the University of Wolverhampton

2001 Awarded an Honorary Fellowship at
 the Royal Institute of British Architecture

 Anish Kapoor lives and works in London

Untitled
1975
Paint, chalk, steel, plaster
274.3 × 121.9 × 182.9

Solo exhibitions

1980 Patrice Alexandre, Paris

1981 Coracle Press, London

1982 Lisson Gallery, London
 Walker Art Gallery, Liverpool

1983 Galerie 't Venster, Rotterdam (organised
 by the Rotterdam Arts Council)
 Walker Art Gallery, Liverpool (Toured to
 Le Nouveau Musee, Villeurbanne/Lyon)
 Lisson Gallery, London

1984 Barbara Gladstone Gallery, New York

1985 Lisson Gallery, London
 Kunsthalle, Basel (toured to Stedelijk Van
 Abbemuseum, Eindhoven)

1986 Kunstnernes Hus, Oslo
 Barbara Gladstone Gallery, New York
 Anish Kapoor: Recent Sculpture and Drawings,
 University Gallery, Fine Arts Center, University
 of Massachusetts, Amherst

1987 *Anish Kapoor: Works on Paper 1975–1987*,
 Ray Hughes Gallery, Sydney (toured to
 MOMA, Brisbane)

1988 Lisson Gallery, London

1989 Barbara Gladstone Gallery, New York
 Kohji Ogura Gallery, Nagoya

1989–90 *Void Field*, Lisson Gallery, London

1990 *Anish Kapoor, XLIV Biennale di Venezia*,
 British Pavilion, Venice (organised by
 The British Council)
 Drawings, Barbara Gladstone Gallery,
 New York

1990–91 *Anish Kapoor Drawings*, Tate Gallery, London
 Le Magasin, Centre National d'Art Contemporain,
 Grenoble (organised in cooperation with
 The British Council)

1991 Palacio de Velazquez, Centro de Arte Reina
 Sofia, Madrid (organised in cooperation with
 The British Council)
 Kunstverein Hannover (organised in
 cooperation with The British Council)
 The Sixth Japan Ushimado International
 Art Festival, Ushimado
 Anish Kapoor & Ban Chiang, Feuerle Gallery,
 Cologne

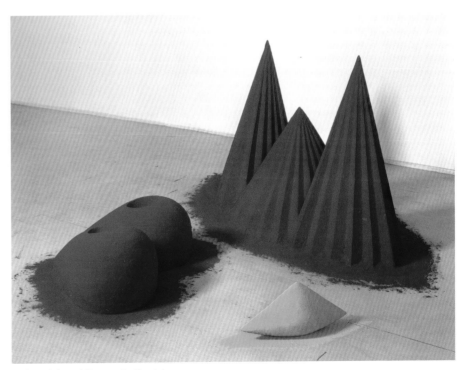

**As if to Celebrate, I Discovered a Mountain
Blooming with Red Flowers**
1981
Wood, cement, polystyrene, pigment
97 × 76.2 × 160; 33 × 71.1 × 81.3; 21 × 15.3 × 97
Tate

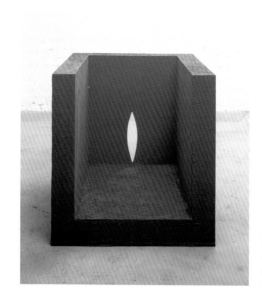

Place
1985
Wood, gesso, pigment
90 × 80 × 80
Private Collection, New York

1992 Galeria Soledad Lorenzo, Madrid
Stuart Regen Gallery, Los Angeles

1992–93 San Diego Museum of Contemporary Art,
La Jolla (toured to the Des Moines Art Center,
Iowa; The National Gallery of Canada, Ottawa;
The Power Plant, Toronto)

1993 Lisson Gallery, London
Tel Aviv Museum of Art, Tel Aviv
Barbara Gladstone Gallery, New York

1994 Mala Galerija, Moderna Galerija Ljubljana,
Museum of Modern Art, Slovenia
Echo, Kohji Ogura Gallery, Nagoya (organised
in cooperation with the Lisson Gallery)

1995 *Anish Kapoor*, DePont Foundation, Tillburg
Nishimura Gallery, Tokyo

1995–96 Prada Milanoarte, Milan
Lisson Gallery, London

1996 *Anish Kapoor. Sculptures*, Aboa Vetus &
Ars Nova, Turku
Anish Kapoor. Two Sculptures, Kettle's Yard,
Cambridge
Galleria Massimo Minini, Brescia
Gourd Project 1993–95, Freddie Fong
Contemporary Art, San Francisco

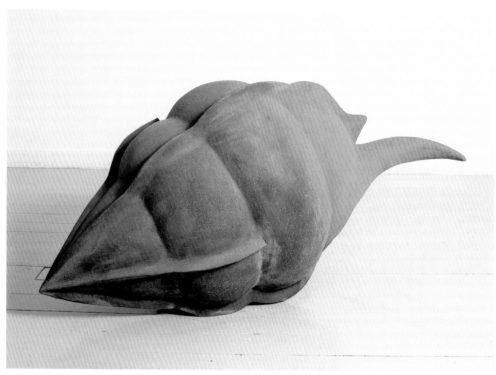

1000 Names
1982
Bonded earth and pigment
Stedelijk Museum, Amsterdam

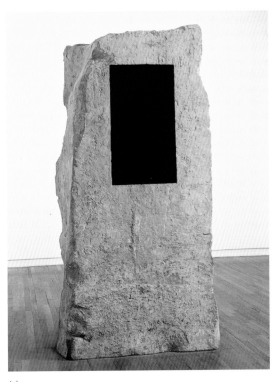

Adam
1988–9
Sandstone and pigment
119 × 102 × 236
Tate

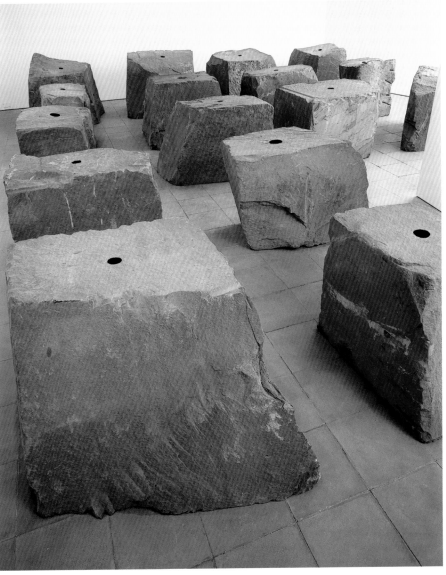

Void Field
1989
Sandstone and pigment
Fondazione Prada, Milan

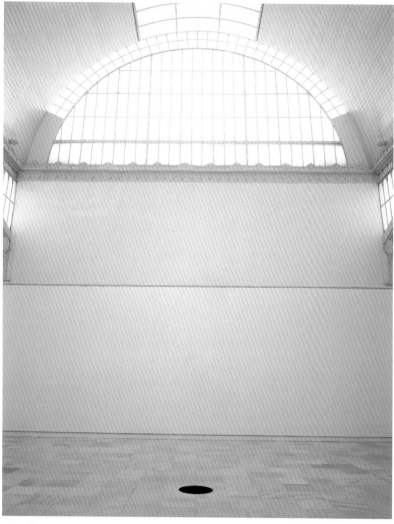

The Earth
1991
Fibreglass and pigment
Installation: Palacio Velasquez, Parque del Retiro,
Centro de Arte Reina Sofia, Madrid

Untitled
1992
Resin and pigment
120 × 120 × 120
Private Collection

7 Ways In
1995
Stainless steel and lacquer
152.4 × 104.8 × 96.5
Adam D. Sender, New York

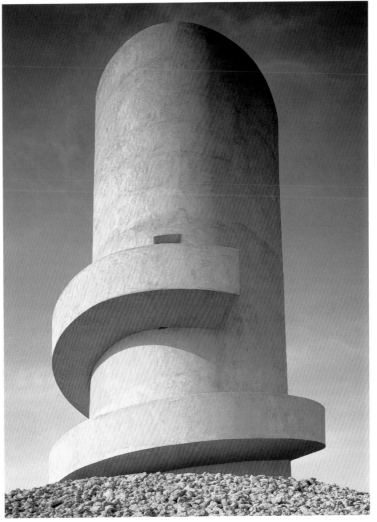

Building for a Void
1992
Concrete and stucco
Height 15m, long axis 8.4m, short axis 6.9m
Project for Expo '92, Seville, 1992 with David Connor

1983 *Figures and Objects*, John Hansard Gallery, Southampton
Beelden/Sculpture 1983, Rotterdam Arts Council, Rotterdam
The Sculpture Show, Hayward Gallery/Serpentine Gallery, London (organised by The Arts Council of Great Britain)
New Art, Tate Gallery, London
Transformations: New Sculpture from Britain, XVII Bienal de Sao Paulo (organised by The British Council: toured to Museo de Arte Moderna, Rio de Janeiro; Museo de Arte Moderna, Mexico DF; Fundação Calouste Gulbenkian, Lisbon)

1984 *An International Survey of Recent Painting and Sculpture*, The Museum of Modern Art, New York
The British Art Show: Old Allegiances and New Directions, 1979–1984, (organised by the Arts Council of Great Britain: toured to the City of Birmingham Museum and Art Gallery, Birmingham; Ikon Gallery, Birmingham; Royal Scottish Academy, Edinburgh; Mappin Art Gallery, Sheffield; Southampton Art Gallery)

1985 *CURRENTS*, Institute of Contemporary Art, Boston
The British Show (organised by the Art Gallery of New South Wales, Sydney and The British Council: toured to the Art Gallery of Western Australia, Perth; Art Gallery of New South Wales, Sydney; Queensland Art Gallery, Brisbane; The Exhibition Hall, Melbourne; National Art Gallery, Wellington)
Who's Afraid of Red, Yellow and Blue?, Arnolfini Gallery, Bristol
20 Sculptures du FRAC Rhone-Alpes, l'Abbaye de Tournus, Tournus

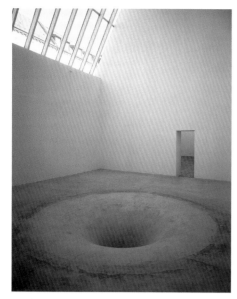

Untitled
1996
Concrete
Installation: 'Betong', Malmo
Konsthall, Malmö, 1996–7

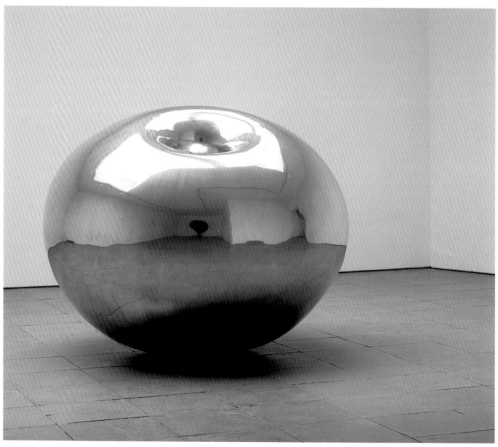

Turning the World Inside Out
1995
Cast aluminium
148 × 184 × 188
Kroller-Muller Museum, Otterloo

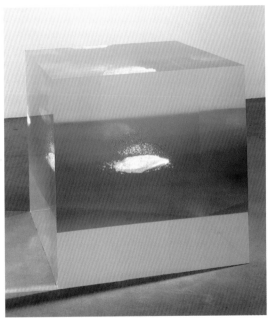

Space as an Object
2001
Acrylic
94 × 94 × 94 cm
Private Collection
Courtesy Barbara Gladstone

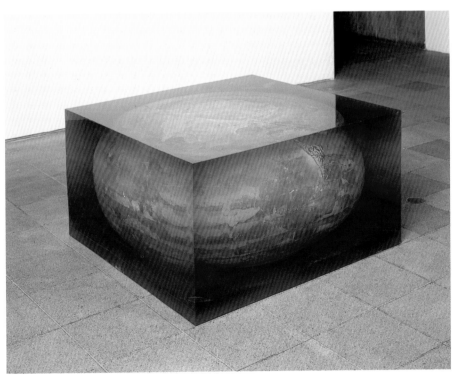

Resin, Air, Space
1998
Perspex
64 × 145 × 165
Private Collection, Germany

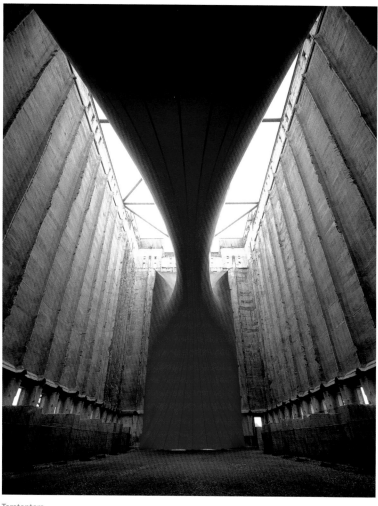

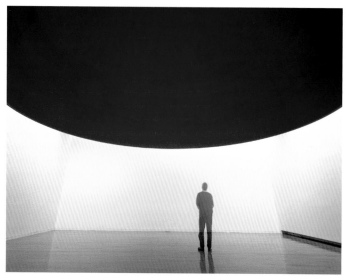

At the Edge of the World
1998
Fibreglass and pigment
500 × 800 × 800
Exh. 'Anish Kapoor', Dobre Espacio, Centro Galego de Arte
Contemporanea de Santiago de Compostela 1998
Private Collection, Antwerp

Taratantara
1999
PVC
Baltic Centre for Contemporary
Art, Gateshead, 2000

1995	*Ideal Standard Summertime*, Lisson Gallery, London
	British Abstract Art Part II: Sculpture, Flowers East, London
1995–96	*Fémininmasculin. Le sexe de l'art*, Centre Georges Pompidou, Paris
1996	*Un siècle de sculpture anglaise*, Jeu de Paume, Paris
	23rd International Biennial of São Paolo
1997	*Belladonna*, Institute of Contemporary Arts, London
	Changing Spaces, The Detroit Institute of Arts, Detroit
1998	*Towards Sculpture*, Fundação Calouste Gulbenkian, Lisbon

	Wounds: Between democracy and redemption in contemporary art, Moderna Museet, Stockholm
	Then and Now, Lisson Gallery, London
1999	*Prime*, Dundee Contemporary Art, Dundee
	Art Worlds in Dialogue, Museum Ludwig, Cologne
	Beauty – 25th Anniversary, Hirshhorn Museum and Sculpture Garden, Washington DC. (toured to Haus der Kunst, Munich. Exhibition catalogue: *Regarding Beauty*)
	Retrace your steps: Remember Tomorrow, Artists at the Soane Museum, London
2000	*Blue*, Walsall Museum
	La Beauté, Papal Palace, Avignon
	Lyon Biennale, Lyon
	Drawings 2000, Barbara Gladstone, New York

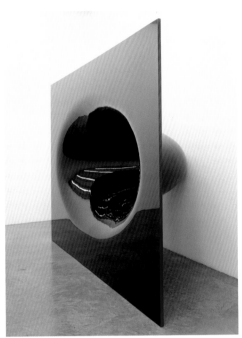

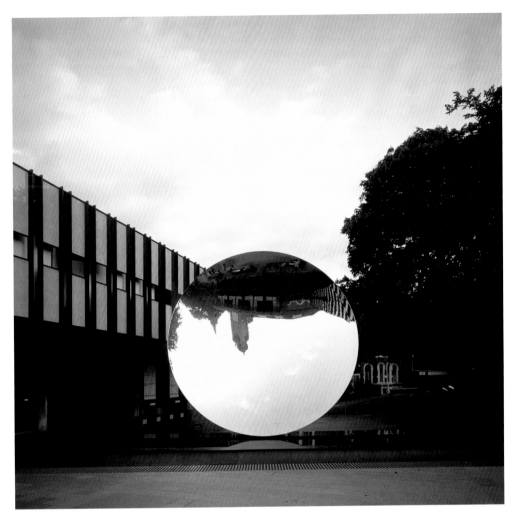

Untitled
2001
Fibreglass
244 × 365.7 × 127
Barbara Gladstone Gallery

Sky Mirror
2001
Stainless steel
Diameter 575
Installation: Public Square, Nottingham
Lisson Gallery

2001 *1951–2001 Made in Italy*, Triennale, Palazzo
dell'Arte, Milan
Shanghai Biennale
Valencia Biennale
BO01, Concepthaus, Malmo
Drawings, Regen Projects, Los Angeles
Field Day: Sculpture from Britain, Tapei Fine Art
Museum, Japan (organised by the Taipei Fine Arts
and The British Council)

2002 *Work on Paper: Anish Kapoor, José Bedia, Richard
Serra*, Quint Contemporary Art, California
Colour White, De La Warr Pavilion
Un ange passe; Seven Venues of Faith, Morat
Remarks on Colour, Sean Kelly Gallery, New York
four women and one pregnant man visiting Oslo,
Galleri MGM, Oslo
Blast to Freeze, Kunstmuseum Wolfsburg
(2002–3)

Blood Cinema
2000
Acrylic and steel
197 × 197 × 51
SFMOMA, San Francisco

Bibliography

COMPILED BY SOPHIE CLARK

Selected solo exhibition catalogues and books

Anish Kapoor. Beeldhouwwerken. Galerie 't Venster, Rotterdam (organized by Rotterdam Arts Council), 1983 (exhibition catalogue). Text by Michael Newman

Anish Kapoor. Kunshalle, Basel, 1985 (exhibition catalogue). Texts by Jean-Christophe Ammann, Alexander von Grevenstein and Ananda Coomaraswamy

Anish Kapoor. Kunstnernes Hus, Oslo, 1986 (exhibition catalogue). Texts by Arne Malmedal and Lynne Cooke

Anish Kapoor: Recent Sculpture and Drawings. University Gallery, Fine Arts Center, University of Massachusetts, Amherst, 1986 (exhibition catalogue). Text by Helaine Posner

Anish Kapoor. Albright-Knox Art Gallery, Buffalo, New York, 1986 (exhibition catalogue). Text by Helen Raye

Anish Kapoor: Works on Paper 1975–1987. Ray Hughes Gallery, Brisbane, 1987 (exhibition catalogue). Interview by Richard Cork

Anish Kapoor. Kohji Ogura Gallery, Nagoya, Japan in co-operation with Lisson Gallery, London, 1989 (exhibition catalogue). Text by Pier Luigi Tazzi

Anish Kapoor. British Pavilion, XLIV Venice Biennale. The British Council, London, 1990 (exhibition catalogue). Texts by Thomas McEvilley and Marjorie Allthorpe-Guyton

Anish Kapoor. Art Random, Kyoto Shoin International, Kyoto, 1990. Edited by Marco Livingstone

Anish Kapoor. Drawings. Tate Gallery, London, 1990 (exhibition catalogue). Text by Jeremy Lewison

Anish Kapoor. Centro de Arte Reina Sofia, Madrid and The British Council, 1991 (Spanish edition of XLIV Venice Bienalle exhibition catalogue)

Anish Kapoor & Ban Chiang. Feuerle, Koln, 1991 (exhibition catalogue). Text by Angel Garcia

Anish Kapoor. Kunstverein Hannover and The British Council, 1991 (exhibition catalogue)

Anish Kapoor. San Diego Museum of Contemporary Art, 1992 (exhibition catalogue). Introduction by Lynda Forsha, essay by Pier Luigi Tazzi

Anish Kapoor. Galería Soledad Lorenzo, Madrid, 1992 (exhibition catalogue). Text by José-Miguel Ullán

Anish Kapoor invita Gary Woodley. Foro per l'Arte Contemporanea, Verona, 1992 (exhibition catalogue). Texts by Erno Vroonen and Paolo Gambazzi

Anish Kapoor. Tel Aviv Museum of Art, Joseph and Rebecca Meyerhoff Pavilion, 1993 (exhibition catalogue). Text by Nehama Guralnik, interview with Homi Bhabha

Anish Kapoor. Moderna Galerija, Ljubljana, 1993 (exhibition catalogue). Text by Zdenka Badovinac

Anish Kapoor, De Pont Foundation, Tilburg, 1995 (exhibition catalogue)

Germano Celant, *Anish Kapoor*, Milan, Charta, 1995

Anish Kapoor, Hayward Gallery, University of California Press, 1998 (exhibition catalogue)

Anish Kapoor, CAPC Musée d'art contemporain de Bordeaux, 2000

Taratantara, BALTIC Centre for Contemporary Art, Gateshead/ACTAR, Barcelona, 2001 (exhibition catalogue)

Taratantara a Napoli, Piazza del Plebiscito, Naples, 2001 (exhibition catalogue)

fig-1, published in association with *Tate: The Art Magazine*, 2001

Selected group exhibition catalogues and books

Objects and Sculpture. Institute of Contemporary Art, London, and Arnolfini Gallery, Bristol, 1981 (exhibition catalogue). Texts by Lewis Biggs, Iwona Blazwick and Sandy Nairne

British Sculpture in the Twentieth Century, Part Two: Symbol and Imagination 1951–80. Sandy Nairne and Nicholas Serota (ed), Whitechapel Art Gallery, London, 1981 (exhibition catalogue). Text by Stuart Morgan

British Sculpture Now. Kunstmuseum, Luzern, 1982 (exhibition catalogue). Text by Michael Newman

XL Biennale di Venezia. Venice, 1982 (exhibition catalogue). Text for 'Aperto '82' by Tommaso Trini

Objects and Figures. New Sculpture in Britain. The Scottish Arts Council, 1982 (exhibition catalogue)

Transformations: New Sculpture from Britain. The British Council, 1983 (exhibition catalogue). Text by Lewis Biggs, Lynne Cooke, Mark Francis, John McEwen, Stuart Morgan, Nicholas Serota and John Roberts

Tema Celeste Museo Civico d'Arte Contemporanea, Gibellina, 1983 (exhibition catalogue). Text by Demetrio Paparoni

Beelden/Sculpture 1983. Gosse and Cees Van der Geer (ed), Rotterdam Arts Council, 1983 (exhibition catalogue). Text by Oosterhaf, with essay by Paul Hefting

La Trottola di Sirio. Centro d'Arte Contemporanea, Siracusa (organized by The British Council), 1983 (exhibition catalogue). Text by Demetrio Paparoni

Figures and Objects. John Hansard Gallery, Southampton, 1983 (exhibition catalogue). Text by Michael Newman

Hayward Annual. Hayward Gallery, South Bank Centre, London, 1983 (exhibition catalogue). Text by Stuart Morgan talking with Kate Blacker

New Art. Tate Gallery, London, 1983 (exhibition catalogue)

Douceur de l'Avant-Garde. C'est Rien de le Dire, Rennes, 1983 (exhibition catalogue)

The Sculpture Show. The Arts Council of Great Britain, 1983 (exhibition catalogue). Texts by Kate Blacker, Fenella Crichton, Paul de Monchaux, Nena Dimitrijevic, Stuart Morgan, Deanna Petherbridge, Bryan Robertson and Nicholas Wadley

Feeling into Form. Walker Art Gallery, Liverpool, and Le Nouveau Musée, Lyon, 1983 (exhibition catalogue). Text by Marco Livingstone

An International Survey of Recent Painting and Sculpture. Museum of Modern Art, New York, 1984 (exhibition catalogue). Text by Kynaston McShine

The British Art Show: Old Allegiances and New Directions 1979–1984. Arts Council of Great Britain, 1984 (exhibition catalogue). Texts by Jon Thompson, Alexander Moffat and Marjorie Allthorpe-Guyton

ROSC '84. Dublin, 1984 (exhibition catalogue)

The British Show. Art Gallery of New South Wales, Sydney, 1985 (exhibition catalogue). Text by Stuart Morgan

La Nouvelle Biennale de Paris. Paris, 1985 (exhibition catalogue)

7000 Eichen. Heiner Bastian (ed), Kunsthalle, Tubingen, 1985 (exhibition catalogue). Text by Heiner Bastian

The Poetic Object: Richard Deacon, Shirazeh Houshiary, Anish Kapoor. Douglas Hyde Gallery, Dublin, 1985 (exhibition catalogue). Text by Richard Francis

CURRENTS. The Institute of Contemporary Art, Boston, 1985 (exhibition catalogue). Text by David Joselit

Entre el Objeto y la Imagen. The British Council and Ministerio de Cultura, Spain, 1986 (exhibition catalogue). Texts by Lewis Biggs and Juan Muñoz

Sonsbeek 1986. International Sculpture Exhibition, Arnhem, The Netherlands, 1986 (exhibition catalogue)

Skulptur – Kunstnere fra Storbrittanien. Louisiana Museum of Modern Art, Humlebaek, 1986 (exhibition catalogue)

Prospect '86. Eine internationale Austellung aktueller Kunst, Frankfurter Kunstverein, Frankfurt, 1986 (exhibition catalogue)

A Quiet Revolution : British Sculpture Since 1965, Museum of Contemporary Art, Chicago and San Francisco Museum of Modern Art, 1987 (exhibition catalogue). Text by Lynne Cooke

Juxtapositions: Recent Sculpture from England and Germany. The Institute for Art and Urban Resources, New York, 1987 (exhibition catalogue)

British Art of the 1980's. The British Council, 1987 (exhibition catalogue). Text by Lynne Cooke, 1987

Inside/Outside. Museum Van Hedendaagse Kunst, Antwerpen, 1987 (exhibition catalogue)

Viewpoint. L'art contemporain en Grande Bretagne, British Council and Museum of Modern Art, Brussels, 1987–8 (exhibition catalogue). Interview by Richard Cork

Simila – Dissimila. Rainer Crone (ed), Kunsthalle, Dusseldorf, 1987–8 (exhibition catalogue). Text by Cornelia Lauf

Europa oggi/Europe now. Amnon Barzel (ed), Museo d'Arte Contemporanea, Prato, 1988 (exhibition catalogue)

Starlit Waters. British Sculpture An International Art 1968–88. Tate Gallery, Liverpool, 1988 (exhibition catalogue). Texts by Martin Kunz, Charles Harrison and Lynne Cooke

Fourth International Drawing Triennale. Kunsthalle Nuremburg, 1988 (exhibition catalogue). Text by David Reason

Carnegie International. Carnegie Museum of Art, Pittsburg, Pennsylvania, 1988 (exhibition catalogue). Text by Kellie Jones

Britannica. 30 Ans de Sculpture. Musée des Beaux-Arts André Malraux, Le Havre; Le Musée d'Evreux-Ancien Evêché; L'Ecole d'Architecture de Normandie, Darnetal-Rouen, 1988 (exhibition catalogue). Texts by Catherine Grenier, Françoise Cohen and Lynne Cooke

La Couleur seule, l'Expérience du Monochrome. Musée St. Pierre, Lyon, 1988 (exhibition catalogue)

British Now: sculpture et autres dessins. Musée d'art contemporain de Montréal, 1988 (exhibition catalogue). Text by Sandra Grant Marchand

Heroes of Contemporary Art. Galerie Saqqarah, Gstaad, 1990 (exhibition catalogue). Text by Akim Monet

British Art Now: A Subjective View. The British Council and Asahi Shimbun, 1990 (exhibition catalogue)

Surrogaat/Surrogate. 15 years of Galerie 't Venster from Kiefer to Koons. Jan Donia (ed), SDU, Uitgeverij, Amstelveen, 1990

Blau: Farbe der Ferne. Hans Gercke (ed.),Wunderhorn, Heidelberg, 1990

Affinities and Intuitions. The Gerald S. Elliott Collection of Contemporary Art. Neal Benezra (ed), The Art Institute of Chicago and Thames and Hudson, 1990 (exhibition catalogue). Text by Lynne Cooke

Dujourie, Fortuyn, Houshiary, Kapoor. Rijksmuseum Kröller-Müller, Otterlo, 1990 (exhibition catalogue). Text by Marianne Brouwer

Made of Stone. Galerie Isy Brachot, Brussels, 1990 (exhibition catalogue)

Trans/Mission. Rooseum, Malmö, 1991 (exhibition catalogue)

La Sculpture Contemporaine après 1970. Fondation Daniel Templon, Fréjus, 1991 (exhibition catalogue)

The Turner Prize 1991. Tate Gallery, London, 1991 (exhibition catalogue). Text by Sean Rainbird

Il Limite delle Cose nella Nuova Scultura Inglese, studio Ogetto, Milan, 1991 (exhibition catalogue). Texts by Enrico Pedrini and Emilio Stabilini

The New British Sculpture, Selected Works from the Patsy R. and Raymond D., Nasher Collection, University of North Texas Art Gallery, Texas, 1992 (exhibition catalogue)

de Opening. De Pont Foundation, Tilburg, 1992 (exhibition catalogue)

New Voices, New Works for the British Council Collection, The British Council, 1992 (exhibition catalogue). Text by Gill Hedley

Art against AIDS, 45th Venice Biennale, Peggy Guggenheim Collection, Venice, 1992 (exhibition catalogue)

British Sculpture from the Arts Council Collection. The Arts Council of Great Britain, 1993 (exhibition catalogue). Text by James Roberts

Another World. Mito Annual '93, Art Tower Mito, 1993 (exhibition catalogue). Text by Yoko Hasegawa

Cerco, Bienal Internacional de Obidos. Modus Operandi, Lisbon, 1993 (exhibition catalogue)

Oliveira, Petry, Oxley (ed.), Texts by Michael Archer, *Installationa Art,* 1994, Thames and Hudson, London, p.55, 1994

Punishment and decoration, Hohenthal Und Bergen, Cologne, 1994 (exhibition catalogue)

A Changing World: Fifty Years of Sculpture from the British Council Collection, The British Council, 1994 (exhibition catalogue)

Contemporary British Art in Print, Scottish National Gallery of Modern Art and The Paragon Press, 1995 (exhibition catalogue)

De Henry Moore ós anos 90. Escultura británica contemporánea, Auditorio de Galicia, Santiago de Compostella (touring to Serralves Foundation, Oporto, Portugal) 1995 (exhibition catalogue)

Arte Inglese d'oggi, Galleria Civica, Modena; Milano, Mazzotta, 1995 (exhibition catalogue)

Brandon Taylor, *Avant-Garde and After. Rethinking Art Now*, New York, Abrams, p.84, 1995

Fémininmasculin, Paris, Gallimard/Electa, 1995 (exhibition catalogue)

Sophie Bowness and Clive Phillpot (ed.), *Britain at the Venice Biennale 1895–1995*, London, The British Council, 1995

New Art on Paper 2, Philadelphia Museum of Art, 1996 (exhibition catalogue)

Contemporary Art at Deutsche Bank London, London, Deutsche Bank, 1996

Un siècle de sculpture anglaise, Jeu de Paume, Paris, 1996 (exhibition catalogue)

Cattedrali d'Arte, Dan Flavin per Santa Maria in Chiesa Rossa, Fondazione Prada, Milano, 1998

Breaking the Mould, British Art of the 1980s and 1990s, The Weltkunst Collection, London, 1998

Vision: 50 years of British creativity, Thames & Hudson. Texts by David Sylvester,David Hockney, Melvyn Bragg, Michael Craig-Martin, Nicholas Serota, 1998

Regarding Beauty, Hirshhorn Museum and Sculpture Garden, Smithsonian Institution, Washington D.C., 1998 (exhibition catalogue)

Artecinema, 5th International Film Festival on Contemporary Art, Teatro Sannazaro, Napoli, 2000

Field Day: Sculpture from Britain, Tapei Fine Art Museum, 2001 (exhibition catalogue)

Selected periodical and newspaper articles and reviews

William Feaver. 'An Air of Light Relief', *Observer*, London, 26 June, 1981

Marina Vaizey. 'Anish Kapoor', *Sunday Times*, London, May, 1982

Caroline Collier. 'Anish Kapoor', *Arts Review*, 4 June 1982, pp.289–290

John McEwan. *Spectator*, London, June, 1982

Michael Newman. 'Anish Kapoor', *Art Monthly*, No 58, July–August 1982, p.15

Michael Newman. 'New Sculpture in Britain', *Art in America*, September 1982, pp.104–114, 177, 179

William Feaver. 'Gas Mask', *Art News*, No 81, September 1982, p.123

'Anish Kapoor. Bombay, Londra', *Domus*, No 636, February 1983, p.69

Michael Newman. 'Le drame du désir dans la sculpture d'Anish Kapoor', *Art Press*, No 70, May 1983, pp.31–33

Michael Newman. 'Figuren und Objekte. Neue Skulptur in England', *Kunstforum*, No 62, June 1983, pp.22–35

Waldemar Januszczak. 'Three into two won't go', *Guardian*, London, 16 August 1983

Edward Lucie-Smith. 'Back in touch with the emotions', *Sunday Times*, London, 21 August 1983

Patrick Kinmouth. 'Anish Kapoor's Shades of Meaning', *Vogue*, August 1983, pp.104–107

Richard Cork. 'Lucid Form', *Evening Standard*, London, 3 November 1983

Michelangelo Castello. 'Se il vero prende corpo', *Tema Celeste*, Vol 1, November 1983, pp.12–15

Michael Newman. 'Discourse and Desire: Recent British Sculpture', *Flash Art*, No 115, January 1984, p.48–55

John Russell. 'Anish Kapoor', *New York Times*, 23 March 1984, Weekend Section

Dan Cameron. 'Anish Kapoor', *Arts Magazine*, March 1984, p.4

Nancy Princenthal. 'Anish Kapoor', *Art News*, Summer 1984, p.189.

Kenneth Baker. 'Anish Kapoor at Barbara Gladstone', *Art in America*, No 72, October 1984, pp.189–190

'A text by Anish Kapoor', *Lo Spazio Umano*, No 3, July–September 1985, p.77.

Marina Vaizey. 'A new star carves out a sculpture for our time', *Sunday Times*, London, 8 September 1985

William Packer. 'The age of discardment', *Financial Times*, New York, 19 September 1985

Sarah Kent. 'Review', *Time Out*, London, 19–25 September 1985

'Noli me tangere' und 'Beruhren gestattet', *Basellandschaft-liche Zeitung*, Liestal, Switzerland, 9 October 1985

Bruce Arnold. 'Close look at new British sculpture', *Independent on Sunday*, London, 24 November 1985

Demetrio Paparoni. 'Spazio di Dio, spazio della Terra', *Tema Celeste*, Siracusa, No 6, pp.46–49, 1985

Lynne Cooke. 'Mnemic Migrations', *Louisiana Revy*, No 2, March 1986, pp.28–32

John Russell. 'Bright Young Talents: Six Artists with a Future', *New York Times*, 18 May 1986, Section 2, pp.1, 31

'New York, Anish Kapoor, Barbara Gladstone', *Artforum*, New York, November 1986

Paul Bonaventura. 'An Introduction to Recent British Sculpture', *Artefactum*, September–October 1987

Marina Vaizey. 'Shaping up to Abstracts', *Sunday Times*, London, 17 April 1988

Rupert Martin. 'The Journey from an Earthly to a Heavenly Body', *Flash Art*, Summer 1988

Mary Rose Beaumont. 'The sculpture of pluralism', *Art & Design*, Vol 4, No 7/8, p.7, 1988

Richard Dorment. 'Vexed questions of colour', *Daily Telegraph*, London, 9 December 1989

William Feaver. 'Voices from the void', *Observer*, 10 December 1989, p.44

William Packer. 'Sculptor with the best of both worlds', *Financial Times*, London, 12 December 1989

Sarah Kent. 'Anish Kapoor', *Time Out*, London, 13 December 1989

Giles Auty. 'Anish Kapoor at Lisson Gallery', *Spectator*, London, 16 December 1989, p.35

Tim Marlow. 'Generation games in sculpture', *Art & Design*, Vol 5, No 3/4, p.63, 1989

Louisa Buck. 'Pigments of the Imagination', *Sunday Correspondent*, London, 13 May 1990, pp.10–14

'Anish Kapoor interviewed by Douglas Maxwell', *Art Monthly*, May 1990, pp.6–12.

Jonathan Watkins. 'Anish Kapoor', *Art International*, Summer 1990, p.86

William Packer. 'British Artists Fly the Flag in Japan', *Financial Times*, 4 September 1990

'What will become of our sensitive skin. . .', *Artforum*, Vol XXIX, No 1, September 1990, pp.130–137

Michael Brensen. 'Anish Kapoor', *New York Times*, 28 September 1990

'Kapoor en Long in Tate Gallery', *Forum International*, September/October 1990

Sarah Jane Checkland. 'No critics please, they're British', *The Times*, London, 2 October 1990

Nelly Gabriel. 'Anish Kapoor, magicien et illusioniste', *Lyon Figaro*, 4 December 1990

Daniel Dobbels. 'Kapoor: la forme de l'ineffable', *Libération*, 8 December 1990

'L'art du silence', *La Suisse*, 31 December 1990

Kenneth Baker. 'Sculptors Go Two-Dimensional', *San Francisco Chronicle*, 20 February 1991

Liliane Touraine. 'Anish Kapoor, De la modification pour principe à un symbolisme de l'universal', *Artefactum*, Vol 8, No.38, April/May 1991, pp.9–11

Paul Overy. 'Lions and Unicorns: The Britishness of Postwar British Sculpture', *Art in America*, September 1991

Stuart Morgan. 'The Turner Prize', *Frieze*, October 1991, pp.4–8

Richard Dorment. 'A Winner in a class of his own', *Daily Telegraph*, 27 November 1991

Roger Bevan. 'Controversy over the Turner Prize short-list', *Art Newspaper*, No.12, November 1991, p.3

'Turner Prize for Anish Kapoor', *Indian Weekly*, December 1991

Yoshiko Ikoma. 'Anish Kapoor: Interview', *Crea*, No.5, 1991

'Journey to the centre of a void', *Independent*, 8 January 1992

Roger Bevan. 'Anish Kapoor wins Turner Prize', *Art Newspaper*, 14 January 1992

Jeremy Lewison, 'I Disegni di Anish Kapoor', *Carte d'Arte*, No.1, Turin, January 1992, pp.26–29

Susan Kandel. 'The Push and Pull of Kapoor's Metaphors', *Los Angeles Times*, October 1992

'San Diego, Kapoor at the MCA', *Flash Art*, Milan, October 1992

Raghubir Singh. 'Banaras Transformed', *Sunday*, Calcutta/London, 1–7 November 1992, pp.86-89

Martin Gayford. 'Watch this space', *Telegraph Magazine*, *Daily Telegraph*, London, 10 April 1993, pp. 50–51

Richard Cork. 'The shapeliness of things to come', *The Times*, London, 23 April 1993, p.35

Roger Bevan. 'Kapoor at Lisson with stage designs', *Art Newspaper*, London, April 1993

William Packer. 'Sculpture never had it so good', *Financial Times*, London, 4 May 1993

Richard Dorment. 'Body of work that cries out to be touched', *Daily Telegraph*, London, 5 May 1993

Geraldine Norman. 'Sculptor creates fibreglass vision', *Independent*, London, 10 May 1993

Jeremy Isaacs, 'A sense of the future', *Modern Painters*, London, July 1993

Thomas McEvilley, 'Venice the Menace', *Artforum*, October 1993, Vol XXXII, No 2

Clare Farrow, 'Anish Kapoor', *Art and Design*, No.33, pp.52–59, 1993

Donald Kuspit, 'Anish Kapoor', *Artforum*, Vol.XXXII, No.7, March 1994

Marta Dalla Bernardina, 'Kapoor e il Sacro', *Titolo*, No.16–17, Perugia, Autumn-Winter 1994, pp42–45

John K. Grande, 'Anish Kapoor', *Espace*, No.25, Montreal, Canada, , Autumn 1994, pp.27–32

Brian Fallon, 'British sculpture here and now', *Irish Times*, Dublin, 18 May 1995

Patricia Bickers, 'Generations of British Sculpture: The British Sculpture Tradition', *Art Press*, No.202, Paris, May 1995, pp.31–39

Sarah Kent, 'Summer Frieze', *Time Out*, No.1301, London, 26 July–2 August 1995, p.50

Tim Hilton, 'Abstract expressions', *Independent on Sunday*, London, 13 August 1995

Christoper Hume, 'Anish Kapoor's Mountain', *Toronto Star*, Section L, Toronto, 26 August 1995

Suman Buchar, 'The tingle factor', *Telegraph Magazine*, Bombay, 27 August 1995, pp.5–11

Tatsumi Shinoda, 'Sculptor Kapoor chooses Japan for new approach', *Asahi Evening News*, Japan, 23–24 September 1995

'Anish Kapoor alla Fondazione Prada', *Flash Art*, No.194, Milan, October/November 1995, p.56

Piero Deggiovanni, 'Arte Inglese Oggi', *Tema Celeste*, No.53–54, Milan, Autumn 1995, p.88

Walter Guadagnini, 'Meditazioni sul vuoto', *Repubblica*, Rome, 4 December 1995

Marco Vallora, 'Kapoor, poeta dell'ipnosi', *La Stampa*, Turin, 22 December 1995

'Anish Kapoor at the Fondazione Prada', *Flash Art*, No.186, Milan, January–Ferbrurary 1996, p.39

Dalia Manor, 'Anish Kapoor, Lisson Gallery', *Art Monthly*, No.193, London, February 1996, pp.38–39

Sherry Gaché, 'Interview. Anish Kapoor', *Sculpture*, Vol.15, No.2, Washington DC, February 1996, pp.22–23

Martin Gayford, 'Confusing for les rosbifs', *Daily Telegraph*, London, 12 June 1996

Frank Whitford, 'Albion market undersold', *Sunday Times*, London, 16 June 1996

William Feaver, 'Impudence is bliss', *Observer*, London, 23 June 1996

Tasneem Mehta, 'The Importance of Being Anish Kapoor', *Art News Magazine of India*, Vol.1, No.2, Mumbai, August–October 1996, pp.36–41

Mona Thomas, 'Les années 80–90, jeunes sculptures anglaises', *Beaux Arts Magazine*, Jeu de Paume, Paris, pp 48–55, 1996

Adrian Searle, 'It came from Planet Blah', *Guardian*, 4 February 1997, p.14

Sarah Kent, 'Hell's belles', *Time Out*, February 1997

Richard Shone, 'Material Witness', *Observer Review*, 6 April 1997

Waldemar Januszczak, 'A true reflection of the age', *Sunday Times*, 13 April 1997

Marina Vaizey, 'An Enduring Inspration', *Art Quarterly*, No.30, Summer 1997

Andrew Lambirth, 'Kapoor: Master of the sexuality within', *Independent*, 27 January 1998

L.B, 'Anish Kapoor, Q & A', *Art Newspaper*, February 1998

Marianne MacDonald, 'The colour issue', *Observer Weekend supplement*, 12 April 1998, pp. 4–8

Andrew Lambirth, 'Embrace the void', *Independent*, 25 April 1998, pp.32–36

Isabel Carlisle, 'Into the wild blue yonder', *New Statesman*, 1 May 1998

Adrian Searle, 'Don't look up. . .', *Guardian*, 5 May 1998, pp.10–11

Tim Hilton, 'It's all in what the eye cannot see', *Independent on Sunday*, 10 May 1998, pp.22–23

William Packer, 'Now you see it, now you don't', *Financial Times*, 12 May 1998, p.19

Lucy Hughes-Hallett, 'The big questions', *Vogue*, pp.175–178, May 1998

Adam Lowe, 'From Sculpture into Print: Anish Kapoor's wounds and absent objects', *Artbyte*, June–July 1998, pp. 12–13

Joerg Bader, 'Anish Kapoor, beauté et peur du vide', *L'Oeil*, October 1998, pp. 73–77

Natasha Edwards, 'Interview: Anish Kapoor – In Search of the Sublime', *Time Out Paris Guide*, Autumn 1998

Simon Morley, 'Holy Alliance', *Tate Art Magazine*, issue 16, pp. 48–53, 1998

'Art in church', *The Tablet*, 5 June 1999, p.776

Fernanda Maio, 'Anish Kapoor', *Arte Iberica*, June, 1999

Martin Gayford, 'Crimson tide hits Tyneside', *Daily Telegraph – Arts*, 28 July 1999

Tom Lubbock, 'Home is where the art is', *Independent*, November 23 1999

'Dome Improvement', p.14, *Art Monthly*, no.231, November 1999

Martin Gayford, 'Art escapes from the gallery', *Daily Telegraph*, Arts, 8 December 1999

Charles Darwent 'Hide and Seek for the Big Players', *Independent on Sunday*, December 1999

BALTIC Newsletter No.6, 1999

Dale Mc Farland, 'Retrace your steps: remember tomorrow', *Frieze*, pp.99–100, January–February 2000

Martin Gayford, 'Looking In', interview with Anish Kapoor, *Modern Painters*, London, March, 2000

William Packer, 'Godforsaken art in a godforsaken place', *Financial Times*, p.20, 4 April, 2000

James Hall, 'Public sculpture has never had it so good', *Independent on Sunday*, p.5, 9 April 2000

Oliver Bennet, 'Blood Simple', *Independent Magazine*, pp.14–15, 6 May 2000

Andrew Graham Dixon, 'The Art of Success', *Vogue*, pp.179–92, London, May 2000

Eleanor Heartney, 'An Adieu to Cultural Purity', *Art in America*, October 2000

Frank-Alexander Hetting, 'Anish Kapoor', *Kunstforum*, Germany, pp.421, October–December 2000

Corinna Lotz, 'Beauty Now. Beauty in Art at the End of the 20th Century', pp.44–45, *Contemporary Visual Arts*, issue 29, 2000

Nigel Reynolds, 'Life is mirrored in art of stainless steel', *Daily Telegraph*, 8 January 2001

Cheryl Kaplan, 'Strange Attractors: Kapoor/Petronio', *Tema Celeste*, January–February 2001, pp. 62–63

Marcus Fairs, 'Kapoor and McAslan's art pavilion trumpets Sally Army', *Building*, February 2001, pp. 16–17

Sholto Byrnes, 'St Pauls and a sculptor's baptism of fire', *Independent on Sunday*, p.3, 25 March 2001

Niru Ratnam, '"I am that other that you want me to be": the Work of Anish Kapoor in 1980's Britain', *Sculpture Journal*, Volume V, 2001, pp.90–96

Toby Treves, 'The Art of Politics: Sculpture at the Millennium Dome', *Sculpture Journal*, Vol V, 2001, pp. 118–122

Mark Irving, 'Flour power', *Independent On Sunday*, 3 February 2002 p.21

Sanjay Suri, 'British Indian sculptor bags celebrated art assignment', *Indiaweekly*, 11 April 2002

Judith Mackrell, 'Kaash', *Guardian*, 13 May 2002, p.16

Debra Craine, 'Journey to the Outer Limits of Space', *The Times*, 15 May 2002, p. 19

Alastair Macaulay, *A fusion of youth and maturity*, *Financial Times*, 17 May 2002, pp. 18–19

Deyan Sudjic, 'It's enough to make you weep', *Observer*, 7 July 2002, p.12

'Dome design that's causing a row over Diana's memorial', *Evening Standard*, 22 July 2002, p.3

'Space Invader', interview by Richard Cork, *The Times Magazine*, 26 September 2002, pp.38–42

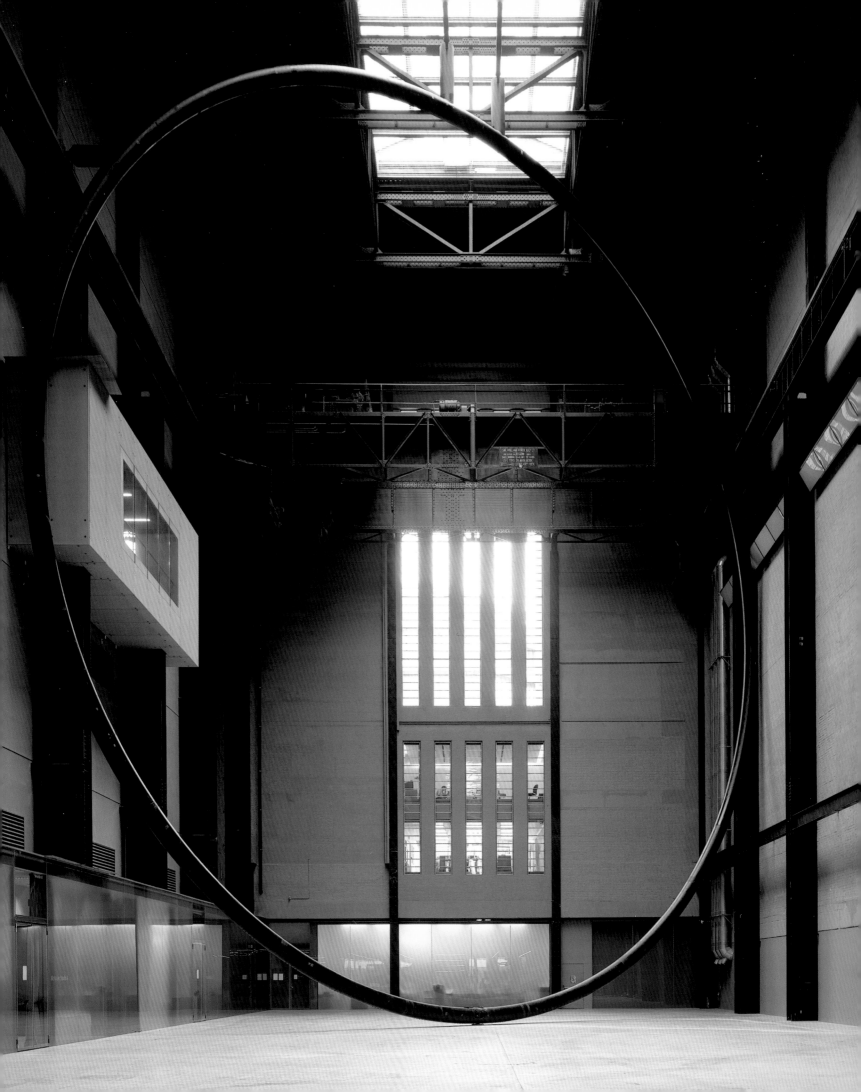

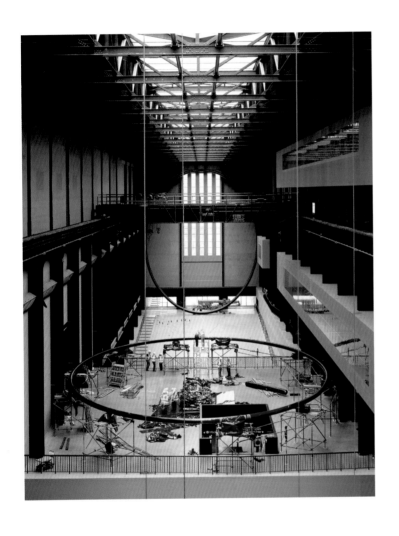

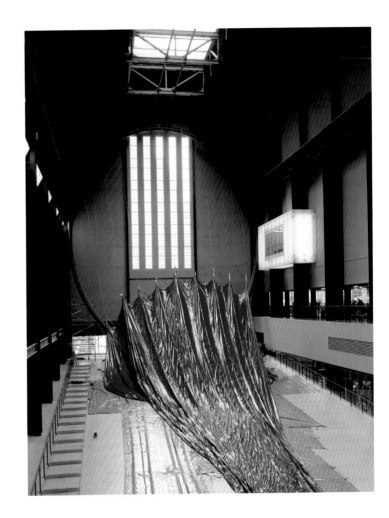

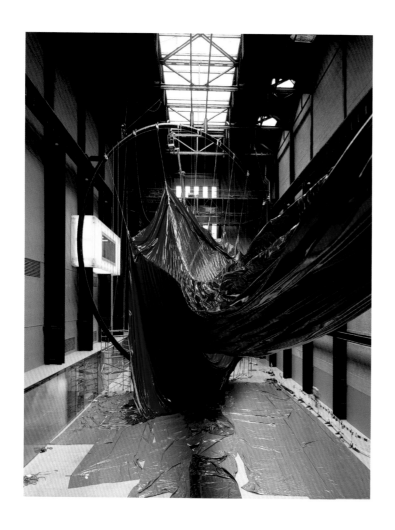
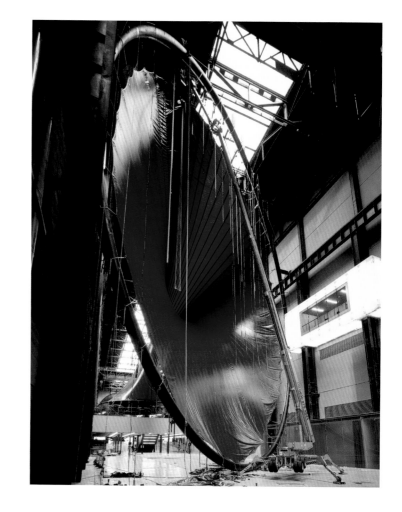

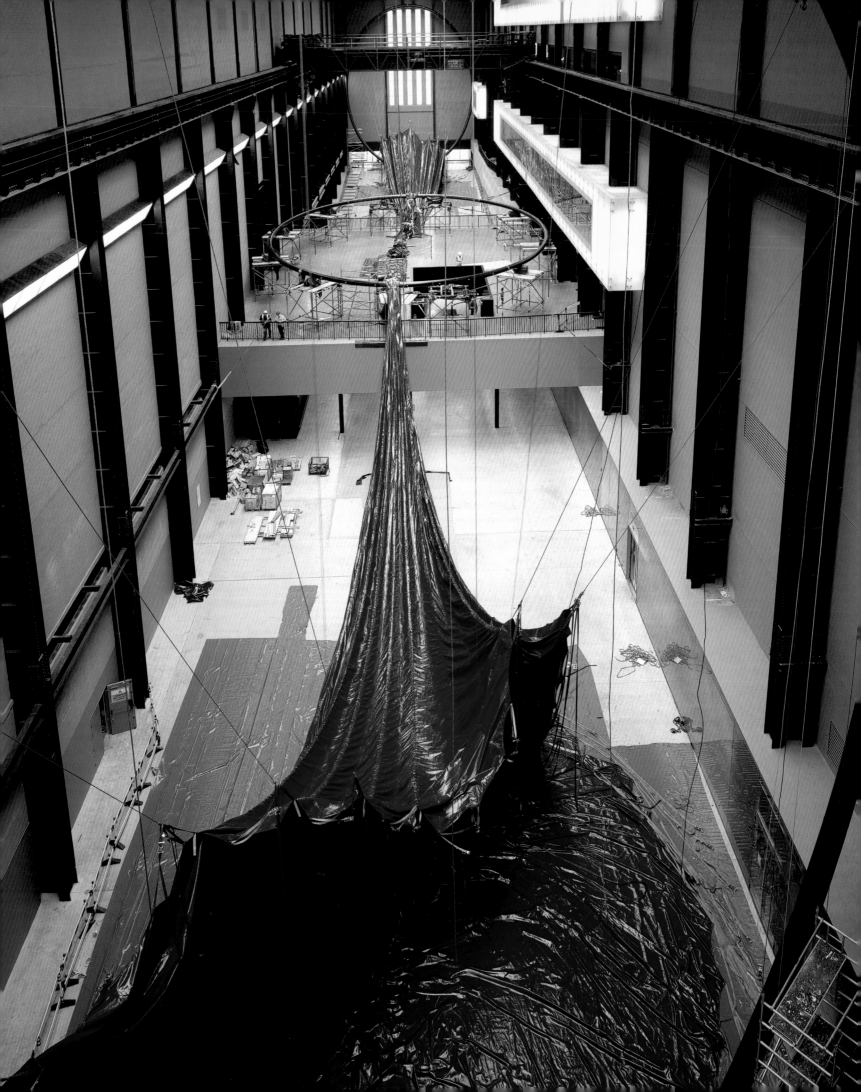

Artist's Acknowledgements

Structure is the first requirement. As if, working outside-in, bodies get skeletons.
Things discover their structure. I am deeply indebted to Cecil Balmond and his
team – Chris Carroll, Tristan Simmonds, Charles Walker and Brian Forster – at Arup for
'enfleshing' the skeletal and de-fleshing the body such that the two are the same.

I dedicate this work to my children, Alba and Ishan, who from the first understood
how 'we' could work together. Our project was spontaneously christened 'Fortent',
enigmatically calling to a hidden content.

Nick Serota and Sheena Wagstaff are due my deepest gratitude for inviting an impossible
project in an impossible time.

Donna De Salvo shadowed and foreshadowed my every move, entering the soul of the
work with curatorial gravity. In that delicate negotiation between creative impulse and
worldly reality, she has masterfully cleared the way so dreams could awake.

I wish to thank Sophie Clark and Phil Monk for their tireless efforts to ensure that
Marsyas came into the world; and Nicola Bion, Philip Lewis and John Riddy for making
this beautiful catalogue.

At my studio Jeff Dyson, Hilary Primett, Tobias Collier, Eddy Jackson and
Zoë Morley have supported me in this and many other endeavours. Thank you.

Nicholas Logsdail has always been ready with advice and encouragement:
he is due my deepest gratitude.

Barbara Gladstone is due my thanks for her continuing support.

Andrea Rose reminded me of Titian. I am grateful.

My wife, Susanne, has lived through every moment of this process with me.
Her wisdom, clarity and love are my guiding light.

ANISH KAPOOR

Index

The Unilever Series
An annual art commission sponsored by Unilever

Unilever

Published by order of the Tate Trustees
on the occasion of the exhibition at Tate Modern, London
9 October 2002–6 April 2003

This exhibition is the third commission in
The Unilever Series

Published in 2002 by Tate Publishing,
a division of Tate Enterprises Ltd,
Millbank, London SW1P 4RG
www.tate.org.uk

British Library Cataloguing in Publication Data
A catalogue record for this book is available
from the British Library

ISBN 1-85437-441-9

Distributed in the United States and Canada by
Harry N. Abrams, Inc., New York

Library of Congress Cataloging in Publication Data
Library of Congress Control Number: 2002116278

Designed and typeset by Philip Lewis at
LewisHallam, London
Printed and bound in Great Britain by
Balding + Mansell, Norwich

Jacket: Anish Kapoor, *Marsyas* 2002 (detail) and
Anish Kapoor, sketchbook drawing (detail)

Measurements of works of art are given in
centimetres, height before width

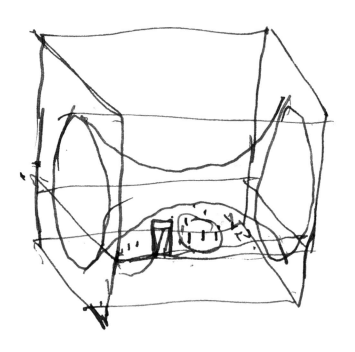